THE ART & DESIGN SERIES

For beginners, students, and professionals in both fine and commercial arts, these books offer practical how-to introductions to a variety of areas in contemporary art and design.

Each illustrated volume is written by a working artist, a specialist in his or her field, and each concentrates on an individual area—from advertising layout or printmaking to interior design, painting, and cartooning, among others. Each contains information that artists will find useful in the studio, in the classroom, and in the marketplace.

Carving Wood and Stone:
An Illustrated Manual
ARNOLD PRINCE

Chinese Painting in Four Seasons:
A Manual of Aesthetics & Techniques
LESLIE TSENG-TSENG YU/text with Gail Schiller Tuchman

The Complete Book of Cartooning
JOHN ADKINS RICHARDSON

Creating an Interior
HELENE LEVENSON, A.S.I.D.

Drawing: The Creative Process
SEYMOUR SIMMONS III and MARC S.A. WINER

Drawing with Pastels
RON LISTER

Graphic Illustration:
Tools & Techniques for Beginning Illustrators
MARTA THOMA

How to Sell Your Artwork:
A Complete Guide
for Commercial and Fine Artists
MILTON K. BERLYE

Ideas for Woodturning
ANDERS THORLIN

The Language of Layout
BUD DONAHUE

Understanding Paintings:
The Elements of Composition
FREDERICK MALINS

Nature Photography: A Guide
to Better Outdoor Pictures
STAN OSOLINSKI

Printed Textiles: A Guide to
Creative Design Fundamentals
TERRY A. GENTILLE

An Introduction to Design: Basic Ideas
and Applications for Paintings or the Printed Page
ROBIN LANDA

Cartooning and Humorous Illustration:
A Guide for Editors, Advertisers, and Artists
ROY PAUL NELSON

Package Design: An Introduction
to the Art of Packaging
LASZLO ROTH

Lithography: A Complete Guide
MARY ANN WENNIGER

Painting and Drawing: Discovering Your
Own Visual Language
ANTHONY TONEY

Photographic Lighting: Learning to See
RALPH HATTERSLEY

Photographic Printing
RALPH HATTERSLEY

Photographing Nudes
CHARLES HAMILTON

A Practical Guide for Beginning Painters
THOMAS GRIFFITH

Printmaking: A Beginning Handbook
WILLIAM C. MAXWELL/photos by Howard Unger

Silkscreening
MARIA TERMINI

Silver: An Instructional Guide
to the Silversmith's Art
RUEL O. REDINGER

Teaching Children to Draw:
A Guide for Teachers and Parents
MARJORIE WILSON and BRENT WILSON

Transparent Watercolor:
Painting Methods and Materials
INESSA DERKATSCH

Nature Drawing: A Tool for Learning
CLARE WALKER LESLIE

Woodturning for Pleasure
GORDON STOKES/revised by Robert Lento

The Art of Painting Animals:
A Beginning Artist's Guide to the Portrayal
of Domestic Animals, Wildlife, and Birds
FREDRIC SWENEY

Graphic Design:
A Problem-Solving Approach
to Visual Communication
ELIZABETH RESNICK

Display Design: An Introduction
to the Art of Window Display,
Points of Purchase, Posters, Signs and Signages,
Sales Environments, and Exhibit Displays
LASZLO ROTH

Oscar White is president of Pach Brothers in New York City, the nation's oldest photography studio. In addition to teaching photography at the college level, he has photographed a wide range of people, including four U.S. presidents. His work is exhibited in the Library of Congress, among other collections.

OSCAR WHITE

The art of photographing people

PORTRAIT PHOTOGRAPHY

A SPECTRUM BOOK PRENTICE-HALL, INC., Englewood Cliffs, New Jersey 07632

Library of Congress Cataloging in Publication Data

White, Oscar.
 Portrait photography.

 (Spectrum art and design series)
 "A Spectrum Book."
 Includes index.
 1. Photography—Portraits. I. Title.
TR575.W45 1983 778.9′2 82-25071
ISBN 0-13-687335-9
ISBN 0-13-687327-8 (pbk.)

This book is available at a special discount when ordered in
bulk quantities. Contact Prentice-Hall, Inc., General
Publishing Division, Special Sales, Englewood Cliffs, N.J. 07632

Dedicated to Judy

10 9 8 7 6 5 4 3 2 1

ISBN 0-13-687335-9

ISBN 0-13-687327-8 (PBK.)

THE ART & DESIGN SERIES.

EDITORIAL/PRODUCTION SUPERVISION BY KIMBERLY MAZUR
PAGE LAYOUT BY CHRISTINE GEHRING WOLF
COLOR INSERT DESIGNED BY ALICE MAURO
MANUFACTURING BUYER: CHRISTINE JOHNSTON

 All the photographs are by the author with the exception of President Franklin Delano Roosevelt,
which is from the Pach Brothers Collection.

Prentice-Hall International, Inc., London
Prentice-Hall of Australia Pty. Limited, Sydney
Prentice-Hall Canada Inc., Toronto
Prentice-Hall of India Private Limited, New Delhi
Prentice-Hall of Japan, Inc., Tokyo
Prentice-Hall of Southeast Asia Pte. Ltd., Singapore
Whitehall Books Limited, Wellington, New Zealand
Editora Prentice-Hall do Brasil Ltda., Rio de Janeiro

Contents

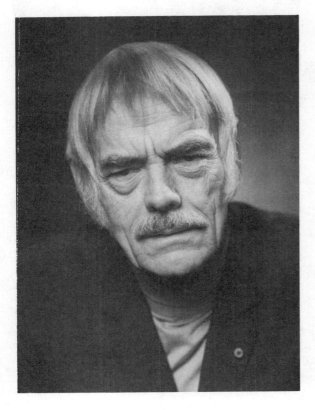

Preface

This is a book about portrait photography. It shows how the portrait photographer determines what picture possibilities exist for a particular person and the way the information is used to produce a good portrait likeness. Even though this is not an elementary book, you need not get involved in any complex study of photography in order to fully understand the material.

The objective of the portrait photographer is to determine that which is unique in a person and to record it on film. This book instructs you in the methods of acquiring this vital information quickly and systematically.

This is also about people—the people who serve as the raw material for the portrait photographer's camera, and it enables you to see things in people you may never have seen before.

All steps between the time the pho-

tographer first sees his subject and the time he trips the shutter on his camera are covered. These steps include lighting, posing, and subject animation.

Good portrait photography does not depend on advanced, supersophisticated cameras. In this book the camera is relegated to the role of a recording device and not to that of a magic box. Technical terms are kept to a minimum.

The material in this book covers the collective experience of generations of portrait photographers, yet it is current. Although technology has given the portraitist previously undreamed of flexibility, the basic objective is still the same—to determine the uniqueness in a person and to record it on film.

The emphasis of this book has been more on concepts than on equipment. Cameras and film are constantly being changed and improved, but these changes have no real effect on the overall quality of portrait photography. The subject should be the main focus of the photographer's attention.

With continued practice your very own portrait technique will emerge. You will supply a personal point of view. Your results will be yet another unique version of how to portray likeness. You will have developed a style of your own.

ACKNOWLEDGMENTS

The information upon which this book is based was acquired during my career as a portrait photographer and teacher. Although I did not realize it at the time, the people who sat before my camera served as the raw material for the concepts covered in this book. My students also bear a certain amount of responsibility for this work. Through them I learned how to convert sometimes complex ideas into simple, everyday language.

I would like to thank the following people who served as the models for the illustrations: Edward Barnes, Fritz Bertoni, Janet E. Cahn, Chow Wen-Chung, Roxanne Dundish, Sherry Dundish, Joanne White Erez, Zvi Erez, The Gomez Family of Marbella, Spain, Dr. Lazlo Gonye, Marilyn Gross, Claire Hennessy, George Kaylor, Suzanne Kaylor, Marilyn Kelly, Theodore Kleodas of Patmos, Greece, Norma Ronson Koppel, Ken McCaffrey, Sallie Nichols, Martha Hamilton Philips, Lesley Retzer, Daniel O. Smith, Roberta White Smith, Stanley M. Smith, Marjorie Steinman, Robert Taylor, and Virginia M. Wolfe.

I appreciate the technical assistance on eye problems given me by ophthalmologist Dr. Edwin Miller.

My special thanks go to Mary E. Kennan, editor for Spectrum Books, for suggesting the idea for this book, and for her constant support and encouragement. I am indebted to editor Kimberly Mazur for her help and guidance with the preparation of the manuscript. I also benefited from the expertise of art director Hal Siegel.

Finally, I am grateful to my wife, Judy, to whom this book is dedicated. She served as my sounding board and shared my frustrations and pleasures during the process of preparing the manuscript.

PORTRAIT PHOTOGRAPHY

The psychology of portrait photography

SUBJECTS ABOUT TO SIT FOR THE CAMERA are faced with a moment of truth. They are usually apprehensive. Rarely are they convinced that the photographer fully understands the photographic problems that peculiarly relate to them.

Actually, there is very little correlation between the way they think they look and the way they appear to others. The mirror image is unreliable. It is affected by mood and the mechanics that go with viewing oneself in a mirror. It is a personal view that is not necessarily shared by others. A minor aberration, almost invisible to anyone else, can assume monumental proportions. A change in a person's emotional state, even if nothing physical has changed, can instantly affect the way he thinks he looks. He nurtures this subjective image and is often startled when he sees himself as others see him.

A minimum requirement for a successful result is the photographer's ability to project an instant and convincing air of

confidence. The subject's concerns regarding his or her appearance should be viewed sympathetically. The photographer should never ignore a problem that is obvious to him and the subject.

Some years ago a man with a badly scarred cheek sat for me. I used all the tools at my disposal in the camera room to eliminate the aberration. My subject was extremely unhappy with the results. It turned out that the disfigurement on the cheek was a dueling scar, a badge of honor. Had I discussed this with him beforehand, I would have retained his mark of distinction and avoided his displeasure. On the other hand, a disfigurement could be the result of an accident. Always discuss the obvious problem with your subject.

There is a tendency for individuals to subconsciously conceal what they feel is unflattering to them. Since they cannot see themselves as others see them, these opinions are very rarely justified. The sen-

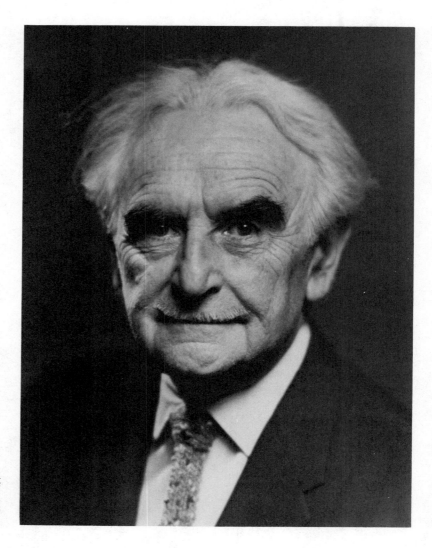

Figure 1.1
The occasion for this portrait of architect Richard Neutra was his election to the American Institute of Arts and Letters.

sitivities of an individual are obvious to an observant portrait photographer even before they are discussed. A person who thinks her nose is long will often carry her head too high, not at all aware of how visible her nostrils have become. The male with thinning hair will sometimes do the same thing. His reaction to what he sees in the mirror is too dependent on his state of mind to make it a reliable guide to his likeness.

Defensive postures of any sort tend to look unnatural and could conceivably give the subject an undeserved air of aloofness.

On occasion the subject will mention problems that are not discernible. Always listen carefully. Never under any circum-stances make light of them. Get as much information as possible before making any photographic decisions. Tell your subject what you plan to do photographically to achieve a pleasing result. For example, a person with a long nose will be reassured if shown that proper lighting and camera elevation will minimize its size.

Be realistic when you tell a subject how you plan to handle a problem. In your desire to be reassuring, there is a danger of overstating the case. It might serve temporarily to put the person at ease, but will cause difficulty when the person sees the photographs. It is best to stay on the conservative side and be rea-sonably sure of accomplishing your pho-tographic goals.

A portrait cannot be considered as an item essential to our well-being. Unlike food and shelter, we can survive very well without it. Yet our reaction to the way we look in a photograph is all out of proportion to its importance in the scheme of things.

As a portraitist, the manner in which you conduct yourself will be reflected in the subject's expression. You should exude an air of professionalism. Develop an economy of motion. Before executing a change, think it out very carefully. Do not give the feeling that you are floundering or depending on trial and error for ideas. If you look puzzled, the subject will lose confidence in your ability.

A portrait subject, unlike a still life, is never static. Even when a person is in a relatively fixed position, almost imperceptible changes in expression are constantly taking place. You should not be an inhibiting influence on this free flow of facial variations. In a sense the subject is you, the photographer. By voice and gesture you will act out the role you wish the model to play.

You are the director. You control the stage and set the scene. The model is cast in the role of a performer. You must see to it that the insecurities do not show. For the most part people look much better than they think they do. The result is your responsibility.

Subject appraisal

PORTRAITURE IS UNLIKE ANY OTHER TYPE OF PHOTOGRAPHY. As an object for photography, the human face is unique. The methods used for recording a good likeness of that face are very different from those used in photgraphing most other objects. The fact that we can identify with each portrait likeness that we see makes each of us a potential critic. Those of us who have tried portrait photography have been made to realize that it is not a random procedure. Like all art forms, it has its own set of disciplines.

The major objective of good portrait photography is to determine that which is visually unique about a person and to record it on film. The areas of search for this uniqueness must, for practical reasons, begin with specific categories of information. It is only through a systematic approach that we can acquire viable information in a short amount of time. The

process of obtaining these facts is a methodical study of the subject, relying on gut reaction and specific "know-how." You cannot depend on a quantity of negatives and the law of averages to come up with the proper answers. The probability of a successful portrait is almost nonexistent if done in this manner.

Do not dwell on photographic decisions. You must learn to zero in on the significant areas of likeness before the subject tires.

BODY PROGRAMMING

Our bodies are programmed to assume certain positions for a particular situation without our thinking of which actions are necessary. For example, we always fold our arms in a similar manner. If we try to fold our arms in a different way, we have to stop and think about the change. The same is true of almost any position the body assumes.

Almost any natural uninhibited mo-

7

tion of our body is a duplication of a previous motion under similar circumstances. A habitual response similar to a reflex tells our body how to accommodate itself to a specific suggestion or situation.

It is important to utilize the subject's body programming in the portrait. The inhibitions of the average person facing a camera cause the natural motions to become restrained and awkward. An important part of likeness is contained in the body programming. If we are to take advantage of this obvious key to likeness, we must use motions and relationships that are consistent with the subject's usual body programming.

We will look into some basic rules and positions that our subjects' bodies must conform to in order to make them appear lifelike and relaxed. These rules make it possible to determine if a particular body position is the usual one for a particular subject. There is a high degree of conformity in the way people position their bodies for particular situations. Our study is based on the conformity that exists between the following body relationships:

- Head and torso
- Head and shoulders
- Head and eyes

These body relationships serve as our guides. They tell us when the subject's body is adhering to its usual body programming and when it is restrained by inhibitions.

BODY POSITIONING

Head and Torso Relationship

Let us assume that we seat our model on a low back chair and ask her to sit erect.

By no stretch of the imagination can this scenario produce a comfortable and relaxed looking portrait (Figure 2.1).

Let us picture this model moving from the sitting position to the standing position. During this change of position we will be taking an imaginary strip of motion picture film. One would assume that any individual picture from this strip of film would represent an instant of motion taken out of context. However, viewing the individual frames without their adjacent pictures would show a person who appears to be suffering from severe arthritis.

To correct this problem, the photographer borrows from techniques that have been in use for centuries in the art of portrait painting. A credible likeness and posture is achieved by creating a composite effect involving the head and the torso. For example, we think of this same person about to go from the sitting to the standing position. She begins by flexing her knees and by leaning forward from the waist. Unlike the previous illustration, she stops the action at this point. Looking at our model in this position where we have abruptly halted the motion, we see the torso leaning slightly forward with the head facing the floor (Figure 2.2). Now we are ready to complete the composite. The subject is asked to keep the torso in this position, but instead of looking down, the head is raised. The result is a relationship in which the torso is in the position of motion and the head is where it would be had the action been completed. It is this composite of the head and torso relationship that makes it possible to produce portraits that do not appear wooden and lifeless (Figures 2.3 and 2.4).

At this point we should also dispel a myth concerning body posture in portrait photography. Erect posture is usually not desirable since it occurs rarely in body motion and makes our models look uncomfortable and unnatural.

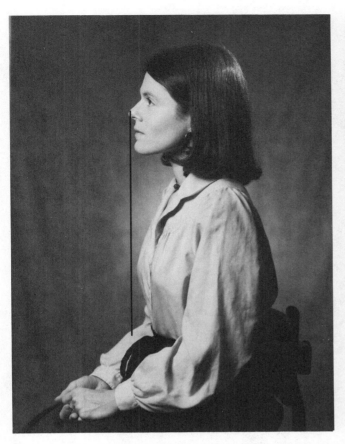

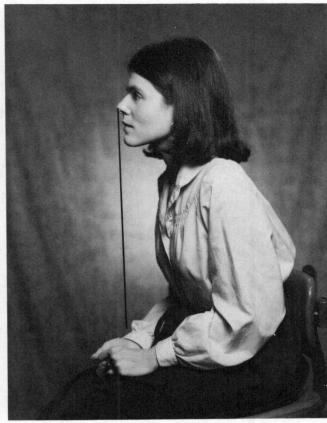

Figure 2.1 (above left)
Subject is sitting erectly in a "mug shot" position.

Figure 2.2 (left)
Subject leans forward from the waist with her head facing downward. This is the first position her body assumes as she prepares to stand up.

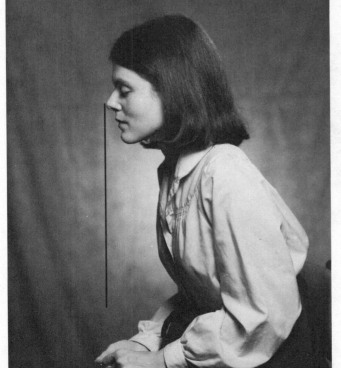

Figure 2.3 (above right)
The model does not complete the motion that would place her in the standing position. Her torso continues to lean forward while she raises her head. We now have a composite of the head and the torso. The composite consists of the torso still leaning forward, preparing to stand up, while the head is in the position it would have assumed had the motion been completed.

Figure 2.4
An enlarged section of Figure 2.3. This is the final product after cropping.

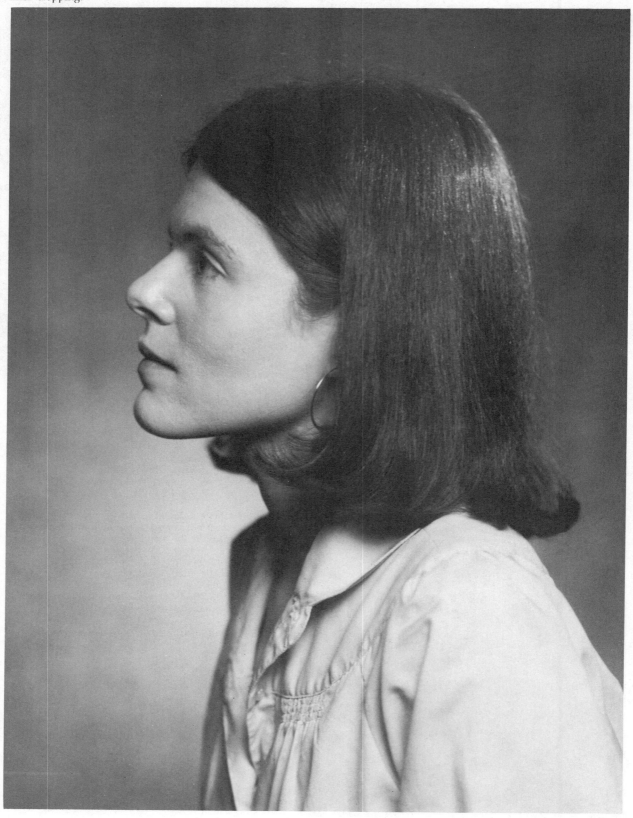

With an understanding of this head and torso relationship, we can achieve the composite effect by simply asking our subject to lean forward from the waist and to raise the head. This is fundamental in any good portrait. When we see this head-torso relationship, our gut reaction is usually positive.

Head and Shoulders Relationship

Our next concern involves the head and shoulder relationships of our models. Whether seated or standing, one of our shoulders always appears to be slightly lower. Since we are not symmetrical, this should come as no surprise.

It may never have occurred to you that the male tilts his head toward his shoulder differently from the way a female does it. In this part of the world, when the male tilts his head, it is usually toward the lower shoulder. It varies in other cultures. The female, on the other hand, tilts her head toward either shoulder. She looks natural and comfortable regardless of which way the head is inclined (Figures 2.5 and 2.6). Ask a seated male to tilt his head toward his higher shoulder. In all probability he will look somewhat effeminate (Figure 2.7). On the other hand, if he tilts his head toward his lower shoulder, he looks more masculine and comfortable (Figure 2.8).

I cannot put too much stress on the importance of understanding these body relationships. One could argue that it is easy to recognize by our own gut reactions a position in which the model looks uncomfortable. This is generally true, but understanding the anatomy of the problem makes it possible to apply an instant remedy when needed.

Figures 2.5 and 2.6
The female subject looks comfortable regardless of which way her head is tilted.

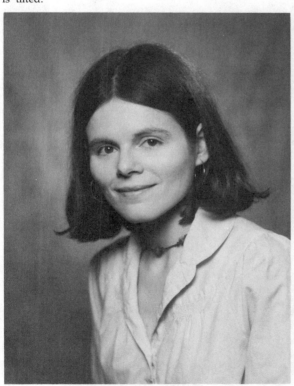

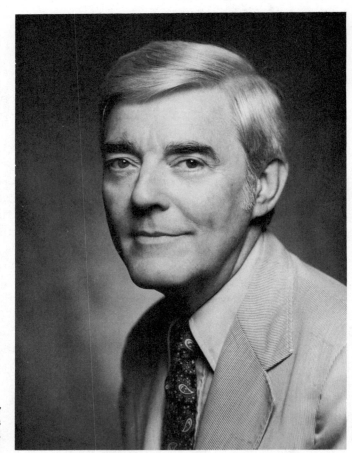

Figure 2.7
The model's head is tilted toward his higher shoulder. He looks strained and uncomfortable.

Figure 2.8
Tilting his head toward his lower shoulder makes him look more relaxed.

Picture a man and a woman sitting next to each other and facing the camera. We ask that they both turn their heads to the extreme right. More likely than not, the man will look less comfortable than the woman unless he also turns slightly from his waist. Through conditioning, the motion of the male body is generally more rigid than that of the female.

Head and Eyes Relationship

The relationship of the eyes to the direction in which the head faces is our next area of study. We ask our subject to face in our direction (also the direction of the camera). He looks and faces us in a conversational position. He looks quite natural and relaxed (Figure 2.9). Next we ask our subject to continue facing in the same direction, but to look to his left or right side. Our model now looks strained and unnatural (Figure 2.10a, b, and c). If his head is turned in this new direction, he once again looks comfortable. From this we can conclude that the eyes and the head should both be in the same direction for our subject to look relaxed. There is one very important exception to this rule. The model always looks natural when his eyes are looking at the camera lens regardless of the head direction (assuming that the head is not turned too far away from the camera position). This is one of the most effective means of giving strength and character to your portrait. The eyes in the picture always appear to be looking at you when this is done (Figure 2.11).

Figure 2.9
The subject is facing the camera with his eyes looking at the camera lens. The head and eyes are pointed in the same direction. Notice how his eyes appear to be looking at you.

Figure 2.11 (right)
A three-quarter view of the subject's face with his eyes looking at the camera lens. This is the only exception to the rule that the eyes and the head should face in the same direction. As in any portrait in which the eyes look at the camera lens, the eyes always appear to be looking at the viewer.

Figures 2.10a, b, and c
The subject's head faces in one direction while his eyes look in a different direction. His eyes look strained and unnatural.

Tying the Pieces Together

We are now ready to utilize this information in our subject appraisal study. Our somewhat inhibited model is asked to sit on a backless or low back stool. Our subject is asked to turn away from the camera so that his body is at right angles to the camera. The subject is directed to turn his head toward the camera. As his head turns toward us, the shoulder farthest from the camera will become lower. We now repeat this procedure by asking our subject to turn in the other direction. A similar lowering of the far shoulder (the other shoulder) occurs. In most instances, if the subject is a male, his head will incline slightly toward the lower shoulder. The turning of the subject from side to side should be repeated several more times. This continual turning usually eliminates stiffness and the inhibited look that the subject first presented. If we are lucky, by the third or fourth time we will see a pattern developing. Our subject's body appears to be programmed in the way it responds to a specific request, no matter how many times the same request is repeated. The model seems to do this effortlessly. We have reached a point in which our model is moving his body according to his natural rhythm.

Unfortunately, it isn't always quite this easy. The inhibitions, awkward postures, and general stiffness require the information we now possess to effect a proper cure. For example, we see a male subject inclining his head toward his raised shoulder. Our gut reaction tells us it looks unnatural. Our knowledge can now tell us why it looks unnatural. We change the tilt of the head and Presto! the problem is eliminated. The subject still looks uncomfortable and too erect. We apply our "know-how" of torso-head relationship by asking our subject to slump forward. The subject now looks even more comfortable.

The head-torso-shoulder relationships have been dealt with, but the model seems to be staring off into space. We direct the model to look at the camera, and we end up with an acceptable head-eye relationship.

We continue to use our gut reaction and specific knowledge to whittle away at any detail that makes the subject look unnatural.

THE FACE

Our next area of study is the exploration of the picture possibilities of a particular face. No face is perfectly symmetrical. One side is always fuller. The eyes usually appear to be unequal in size. Laugh lines (the lines that run from the nose to the lip line) are always dissimilar. There are many less obvious factors that account for this lack of symmetry. Despite these differences, however, a person depending on memory to appraise a member of his or her family, cannot recall or describe the individual in these specific terms.

Our recall is usually limited to stature, coloring, hair, and age. We seem to remember nonvisual qualities—the sound of a voice, the fragrance of a perfume. The mechanics of recognition are not usually dependent on "mug shot" identification alone. Since portrait photography must rely only on visual likeness, we must seek out other nuances that are peculiar to a particular person. This is really the essence of the problem.

Most people have been conditioned to think of their faces as looking less full than they actually are. This becomes apparent when we see a picture of ourselves and find that the face looks fuller and more jowly than we expected it to be. The reason for this discrepancy is our inability to see ourselves in the mirror the way

others see us. The mechanics of vision that create this illusion of leanness are as follows: The medicine cabinet mirror is where we usually scrutinize ourselves. Conditions are far from ideal. The light is usually directly overhead and we are very close to the mirror. This results in a triangulated slimmer version of our face. The poor perspective caused by the closeness to the mirror and the overhead light has created a condition that has made us two-faced. There is the face we see and the face the rest of the world sees. Those of us who think we look like an emaciated version of Abraham Lincoln are shocked to find that we have pudgy cheeks. Another mechanical problem exists. If it were possible to see ourselves in a mirror the way others see us, we would have to look into our own eyes and see the rest of the face at the same time. Since this cannot be done, we are unable to get a glance impression of ourselves. We must settle for a series of scans of the face which results in a more triangulated and narrower version.

Knowing that one side of the face is narrower and that fullness of the face is a major concern of our subject, it makes good sense to deemphasize the heavier side. A good way to get the information quickly is to study both sides of the model's face as seen from three-quarter views of each side of the face. You can begin by asking the model to turn to the left or right. Observe the far cheek line that you see outlined against the background. Turn the model in the opposite direction and look at the other cheek line. Go back and forth several times so that you can make comparisons between the sides. In most instances, since the face is not symmetrical, you will see differences in the shape and fullness of the far cheek as seen outlined against the background. In one of these positions the face will look fuller because the outline of the cheek will appear to protrude further into the background. (See Figures 2.12 through 2.15.)

Figure 2.12
Note the protruding cheek outlined against the background. It makes the face appear broad.

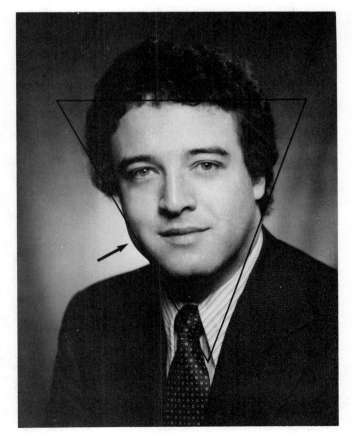

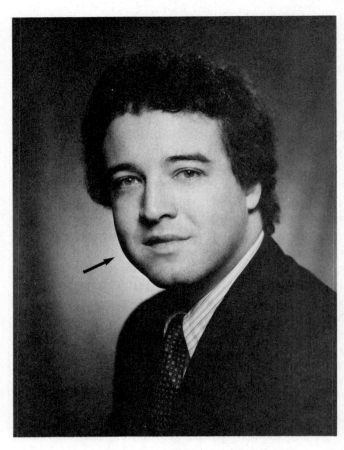

Figure 2.15 (right)
In a front-face view, the protruding cheek is not outlined against the background. This camera angle is another good choice for the subject.

Figure 2.13 (left)
When the subject turns further in the direction of the protruding cheek, the face looks fuller.

Figure 2.14 (below)
The subject's face looks narrower from this side than it does in Figures 2.12 and 2.13. This is an excellent angle for minimizing the fullness of his face.

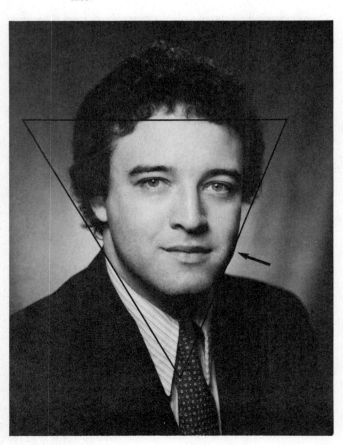

18

There are several other factors that should now be evaluated. As portrait photographers, the expression or laugh lines are of vital concern. These are the lines that start near the nostrils and extend down to the area of the lip line. As in other parts of the face, these lines are not symmetrical. They vary in length, depth, and in shape. The side of the face with the more horizontal line generally looks less severe than the side with the more vertical line. Each face is a mixture of tragedy and comedy. These dissimilarities in the laugh lines can result in a person appearing smug and sarcastic from one side of the face and not from the other side. This is especially true when a smile is attempted.

The eyes appear to differ in size. The eyelids are different, making one eye appear more open and one more squinting. One upper lid tends to sag a bit more and covers more of the iris and pupil.

We can begin to explore our subject's face for the best picture possibilities keeping in mind the following items:

1. Shape of the face (full and narrow sides)
2. Expression or laugh lines
3. Apparent size of the eyes

If we are lucky, the assets will all be on one side of the face with the liabilities on the other side of the face (a good side and a not-so-good side). This is very rarely the way it works out. We now come to the part where we have to make some value judgments. The choices call for a trade-off. For instance, our subject's face looks narrower and generally more attractive from the left side, but the left eye looks much smaller than the right. Would you prefer a fat cheek and a normal size eye to a narrower cheek and a slightly squinting eye? Let us throw another problem into the pot. The subject's left side shows a very horizontal expression line which makes him look somewhat sarcastic.

In actual practice, the skilled portraitist can minimize most of these problems. The important thing at this stage of our study of portraiture is to be able to appraise and recognize these problems. We must understand the causes of these negative gut reactions. Without this knowledge, we cannot make deliberate and dramatic instant corrections. We must tie invisible imaginary strings to the different areas of our model's face so that we may manipulate him or her the way we tune a musical instrument.

Let us summarize the items we should look for in our initial subject appraisal:

1. Head-torso relationship

The subject should lean slightly forward from the waist to create a composite effect between the head and the torso. With the head in the erect position we have bracketed a motion.

2. Head and shoulder relationship

For male subjects, the head should be inclined toward the lower shoulder. For female subjects it can be either shoulder. Usually the female looks more feminine when the head is inclined toward the higher shoulder.

3. Head and eyes relationship

The head and the eyes should always face in the same direction. The only exception is when the eyes are looking at the camera lens.

4. Facial shape

Check three-quarter views of both sides of the face. From each position observe the line of the far cheek. The side from which the cheek line protrudes furthest into the background usually indicates the side from which the subject's face looks heavier.

5. Difference in expression or laugh lines
6. Apparent variation of eye sizes

As mentioned earlier, the mechanics of recognition are not dependent on mug shot identification alone. Most of us have experienced situations in which a familiar figure is sighted at a distance. As we approach the person, doubts begin to develop and we question our initial reaction. Finally it takes almost eyeball contact to establish the identity. It is reasonable to assume that gait, posture, and body programming provided some of the clues, since at a great distance clinical identification is not a factor.

The techniques outlined in this chapter will make it possible for you to get reliable subject information quickly.

For a good portrait likeness you must make an accurate appraisal of the subject's picture possibilities.

CHAPTER THREE

Lighting

THE BASIC CONCEPTS OF PORTRAIT LIGHTING have remained unchanged for over a century. Since these concepts are based on lightings that are present in our environment, they are unlikely to vary appreciably in the future.

Lighting technology, however, has been in a constant state of flux. The introduction of strobe lighting has had a tremendous impact on portrait photography.

Some of the more expensive and sophisticated strobes have built-in modeling lights. The modeling lights remain on all the time. The photographer uses the modeling lights as guides in the placement of the strobes. In theory, during the exposure, the strobe flash will illuminate the subject in a manner similar to that of the modeling lights. In actual practice, it is fairly close but not exact.

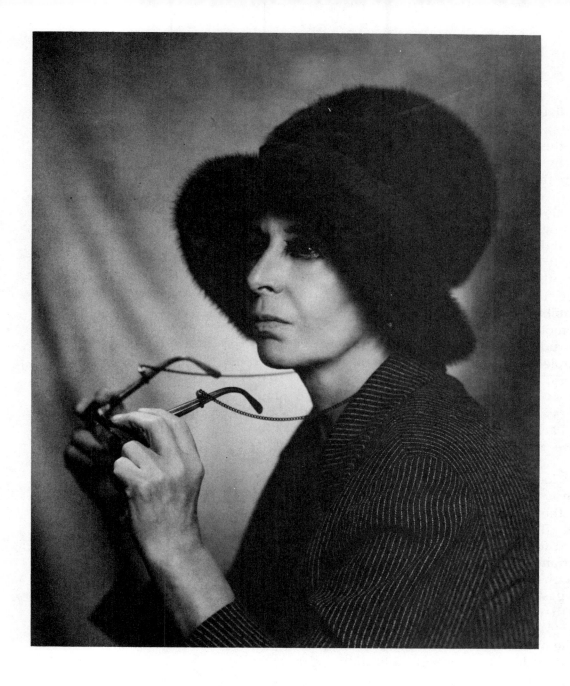

Although strobe lights are now widely used in portraiture, the incandescent, or continuous, light is very much alive. Because of the short duration of a strobe flash, it is impractical to teach portrait lighting with the aid of a light that is visible for but an instant. You cannot accurately visualize the end result. Therefore, for the purposes of our study, we will use incandescent continuous light. Strobe lights can be substituted after you have become familiar with the concepts of portrait lighting.

New types of lighting continue to emerge. The fundamentals of portrait lighting can be applied to almost any source of illumination. The emphasis of our study will be on the principles of portrait lighting rather than on the equipment.

It is likely that you will find use for both types of lighting. They are often used together. Do not develop a dependency on any particular type of equipment.

Learn the principles of portrait lighting so that you will not become a prisoner of electronics.

Lighting the face seems to be one of the least understood skills in portrait photography. It is often done in a mechanical manner without a real understanding of its proper function. Without these skills, the probability of achieving a pleasing result is remote.

The rudiments of facial lighting are quite simple. Once you learn to understand them, you will have taken a giant step in your photographic education. Our study does not require that you have a technical background. It is based on common sense and easily understood principles.

If we look at paintings done after the Renaissance we will see a striking similarity in the lightings that were used on the faces. The same lightings are still being used today in portrait photography. The portrait photographer cannot take credit for the lightings that have evolved from the past. The principles are as sound today as they were before the camera was invented. We have copied and often abused them. Our study will be based on the understanding and proper utilization of these principles.

THE MAIN LIGHT

Most portrait lighting situations are based on the use of a single large main light to provide the basic illumination of the subject. The main light is the portrait photographer's paint brush. The other lights that we use are for ornamental purposes. Regardless of how many additional lights we use on our subject, the main light holds the key to the success of the portrait.

The light must not be too bright. The subject should be able to tolerate its intensity with reasonable comfort. If the subject is forced to squint, a good likeness is out of the question. There is also a matter of the pupil size of the subject's eyes. We are accustomed to seeing a certain pupil size in normal room light. We subconsciously relate the size of the pupil to the amount of light. If the pupils are shown as two pinpoints, the way they would appear in very intense light, the subject would look unnatural.

The main light should be capable of providing an illumination that resembles daylight in a shaded area. It is, after all, what the north light coming through a skylight is to the portrait painter. To function effectively our main light must be soft and gentle. Whether working in color or in black and white, the problem remains the same. The quality of the illumination emitted by the main light must not alter a subject's likeness by being unduly harsh. (A reliable main light can be built by the average photographer at a modest cost. Chapter Fifteen provides additional information.)

The illumination provided by the main light should have the following properties:

1. Fairly low light level to keep the pupils at normal size.
2. Adequate diffusion so that the skin will not look harsh and blotchy.

It is the proper use of this single dominant light source that makes it possible for us to literally paint with light. Skillfully used, we can maintain intimate control over the visual impressions we wish to create with our subject. The heavier face can be made to appear thinner,

the thin face heavier, the crooked nose straighter. Many other visually desirable changes are possible.

A person's skin is a bas-relief surface. On close inspection we can observe the hills and the valleys of the facial surfaces. Unlike a sheet of glass, it has texture and slight color pigment variations. It contains part of our identity in a gentle, unobtrusive way. No statue can possibly duplicate these unique textures. If the light is too harsh it will not penetrate the little valleys of the skin surface. The effect will be a light and shadow situation where only the raised portions of the skin are illuminated. The valleys remain in shadow resulting in a rough, leathery, unnatural skin texture. Softer lighting is always more favorable to a person's appearance.

Despite the desirability of retaining these subtle keys to our likeness, we see portraits where the skin looks like leather—or even worse. The subject must surely feel dismayed when viewing these photographs. A properly designed and diffused main light will go a long way toward the elimination of this problem. The correct tool is always needed to do the proper job.

Positioning the main light is not a random procedure. It requires specific and logical steps. These steps will depend on your visual observations rather than on tape measures. Since each model is unique, no single solution will work in every situation.

The first problem is to determine an approximate height for the main light. We start by placing the light three to four feet from the model and slightly higher than the head. Ask the model to look straight ahead and alternately raise and lower the light. Keep looking at the model's eyes while you do this. You should be able to see a single highlight in each eye. (The highlight is the image of the main light reflected in each eye.)

As you raise and lower the light, try to observe the change in the position of these eye highlights. The clue for the proper main light elevation is in the position of these highlights. Ideally they should position themselves just below the upper lids. In the course of this exercise you can observe the problems that the other eye highlight positions create.

When the light is lowered to eye level, the highlight appears to be near the center of the pupil. This makes the model's eyes look strange because this lighting is unlikely to occur under normal room illumination (Figure 3.1). If the light is raised too far above eye level, as in Figure 3.2, the highlights completely disap-

Figure 3.1
Highlights are near the center of the eyes. The main light is too low. Note the unnatural look of the eyes.

Figure 3.2 (left)
The main light is too high. Eye highlights are absent. The eyes look lifeless.

Figure 3.3 (below)
The eye highlights are just below the upper lids. This is the clue to the proper main light elevation. The subject's eyes look natural.

Figure 3.4
A portrait of artist Balcomb Greene. Although the eye highlights are absent, it is a striking portrait.

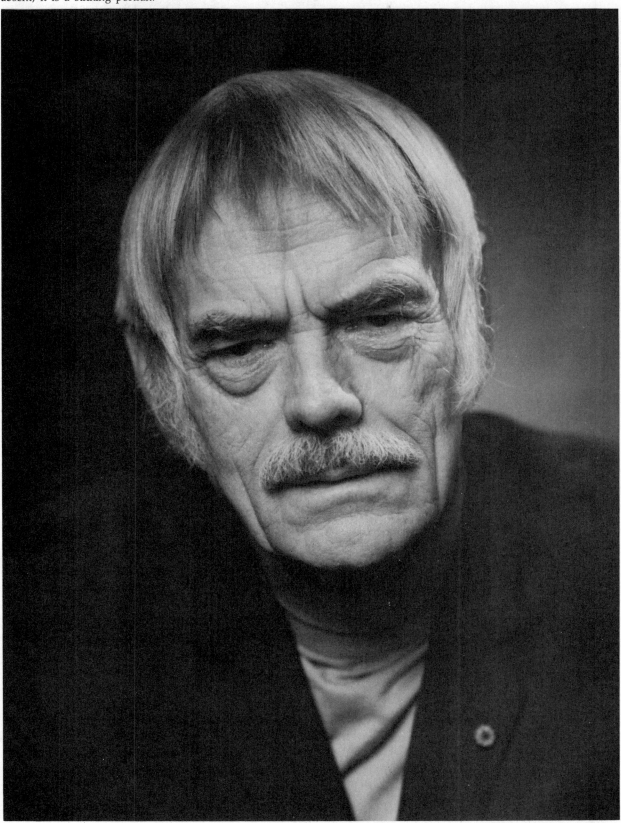

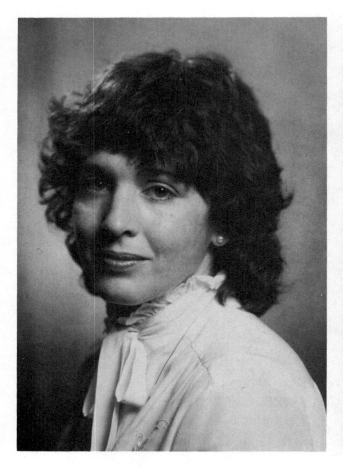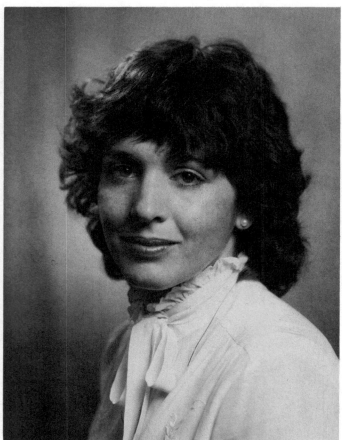

pear, making the model look lifeless. It is fairly obvious that the model looks best when the highlights are placed just below the upper lids. In addition to looking more natural, it is easy for the subject to tolerate the light without squinting (Figure 3.3).

On occasion, especially with elderly people, you might experience difficulty in getting highlights to show in both eyes. One upper eyelid is often lower and covers more of the eye. It is usually best to settle for a single highlight or none at all rather than to risk an unnatural look by lowering the light too much (Figure 3.4).

With the main light positioned at the proper height we can begin to explore its effect on the face. Our model is asked to turn to the right (you can start from either side) and to look toward the camera. From the camera position we see a three-quarter view of the face (a full face with one ear visible). (See Chapter Two, Sub-

ject Appraisal.) With the main light placed slightly to the right of the camera we illuminate the broad side of the face, the side with the visible ear (Figure 3.5). Let us now move the light a bit to the left so that it is close to the camera. Note the effect on the shape of the face caused by the change of the main light's position (Figure 3.6).

Next we move the light further to the left so that it is on the other side of the camera position. It now illuminates the narrow side of the face (Figure 3.7). Go back and forth several times so that you become familiar with the changes that occur in the appearance of the face. Each position of the main light presents a different facet of your subject's face. You begin to discover that your model is made up of many different faces, depending on your main light's location.

Since the results from these light position changes are reasonably predictable,

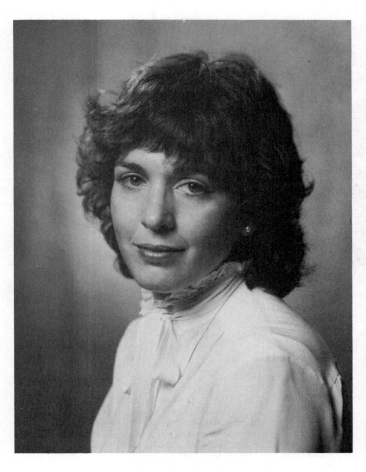

Figure 3.5 (far left)
Main light on the broad side of the face.

Figure 3.6 (middle)
Main light almost directly (but not quite) in front of the face.

Figure 3.7 (left)
Main light on the short or far side of the face.

we do not have to rely on trial and error to get the effects we want.

Keeping the following information in mind will help you cope with most facial types.

The face looks its fullest when the main light is on the broad side. As the light is moved away from the broad side, the face appears narrower. It looks narrowest when the main light illuminates the narrow, or short, side of the face. The changes can be subtle or dramatic, depending on how far the light is moved.

Even though we are able to manipulate the shape of a face, we do not have to worry about the person's likeness changing. Each of these variations is similar to a lighting situation that could occur in normal room illumination.

The selection of the main light position is the most important lighting decision you have to make. Additional lights, though necessary, are used to comple-

ment and ornament the basic main light illumination.

THE FILL-IN LIGHT

One of the most important additional lights is the fill-in light. The face illuminated only by the main light will show harsh shadows in the areas not covered by the light. In most instances it is desirable to lighten these shadows. This can be done by adding an additional light or by using a reflector.

When a fill-in light is used it is generally placed near the camera position. (See Chapter Fifteen for fill-in light design.) The fill-in light can create problems if improperly used.

As mentioned earlier in this section, showing a single highlight in each eye is

29

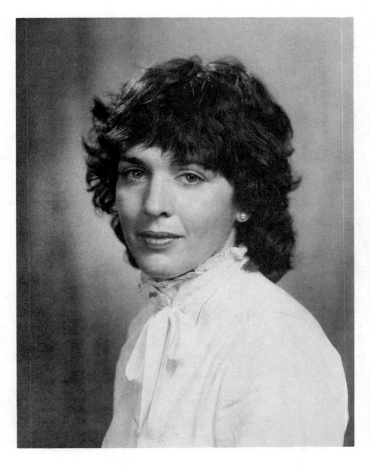

Figure 3.9 (right)
Fill-in illumination supplied by a reflector.
The eyes are not affected. Note how
brilliant the eyes are when you compare
them to Figure 3.8.

Figure 3.8
A fill-in light is introduced on the shadow
side of the face causing additional
highlights to appear in the eyes. The
additional highlights tend to reduce the
dominance of the original highlights. As a
result, the eyes look bland.

desirable. Problems occur when the fill-in light imparts a highlight of its own resulting in two highlights in each eye (Figure 3.8). The additional highlight makes it difficult to tell the direction in which the model is looking. It can also give the subject a staring look. Showing only a single highlight gives brilliance to the eyes and strength to the portrait.

Constant care and awareness of this problem are necessary to properly position the fill-in light. It is important to learn to locate the fill-in light by its behavior on a particular face rather than by measurements that are mechanical and unreliable.

Start by placing the fill-in light next to the camera, just a bit above the model's eye level. Move it back and forth and from side to side. The change in the subject's face will be very noticeable. The harsh shadows created by the main light

will begin to take on a subdued appearance. Our model's face assumes a more natural look since the lighting is more like comfortable room illumination. With a bit of practice you will soon learn to add the proper amount of fill-in light for each subject's face. A good rule of thumb is to fill in and soften the shadows without affecting the dominance of the main light.

REFLECTORS

An alternate means of supplying fill-in illumination is by the use of a reflector. It is considered a superior method and has fewer hazards than the fill-in light. Double eye highlights do not occur and it is easier to judge the effect visually (Figure 3.9). In fact it is difficult to make a serious

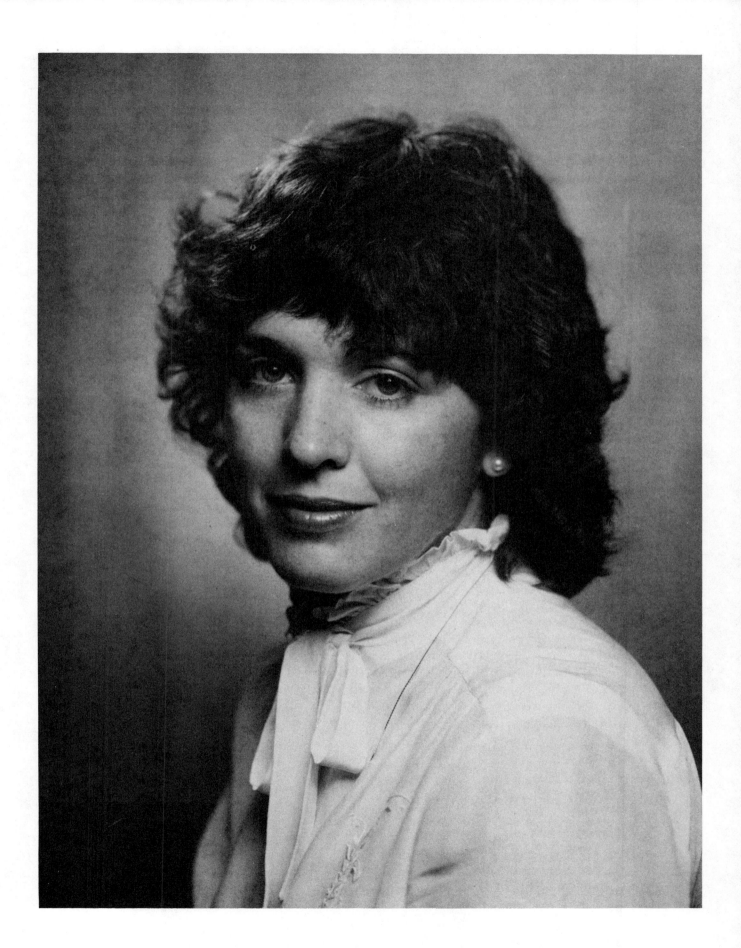

mistake using this method.

The best argument for its use is the reflector's ability to apply illumination in a manner similar to what we see in our daily activities. We are accustomed to looking at people as they are lit by normal room light and daylight. In each instance the walls, floors, and all other reflective surfaces supply the fill-in illumination. We are likely to relate to this type of lighting because of its familiar look.

A good serviceable reflector can be made from easily obtainable material. It can be a piece of white cardboard, a sheet, a towel, or a piece of aluminum foil pasted to a cardboard. Almost any material with a reflective surface will do. (See Chapter Fifteen for details.) The reflector is generally mounted on a light stand so that it can be moved easily.

Positioning the reflector is relatively simple. With the main light in position, place the reflector to the side of the subject. It should be on the side opposite the main light. The object is to capture part of the main light's illumination and to reflect it back onto the model's face. Try moving the reflector by turning it and varying its distance from the subject. Very visible changes will occur. You now have very effective control over the amount of shadow on the subject's face. You have another brush with which to do your light painting.

Two methods of supplying fill-in illumination have been described. Although both systems are used, my preference is to use the reflector method.

THE BACKGROUND LIGHT

The background light generally consists of a small light bulb (75 to 150 watts) mounted on a short light stand (see Chapter Fifteen). The light is placed between the subject and the background so that the subject's body completely conceals the light from the camera view. One of the functions is to provide a separation between the model and the background.

As a lighting tool, its uses go far beyond merely illuminating a background. The background light is also used in the composition of the portrait. It can be made to direct the viewer's eye to a particular section of a picture. The same background can be used to produce many different gradations of tone by simply adjusting the position of the background light. A single medium gray background can be given a tonal range from almost white to almost black. Whether in black and white or in color, this flexibility is convenient.

Our first situation for exploring the use of the background light will be with a subject whose hair color is of a medium shade. As we darken the background, the hair becomes more prominent. This is an effective means of giving the subject's hair importance. The variety of available background shades is infinite. We can lighten or darken the background by simply moving the background light (see Figures 3.10 and 3.11).

Another practical use of the background light is illuminating the area directly behind the model, leaving the outer edges of the picture darker. This gives a frame effect to the portrait.

At this point we are ready to try a more dramatic application of background lighting. The subject will be placed in the three-quarter position. While in this pose we will light the background in three different ways:

1. First we place the light between the subject and the background, giving a halo effect to the background. The center is fairly bright but gets darker as it goes

Figure 3.10
On a light background the hair is not particularly conspicuous.

Figure 3.11
A dark background gives prominence to the hair. A spotlight adds additional brilliance.

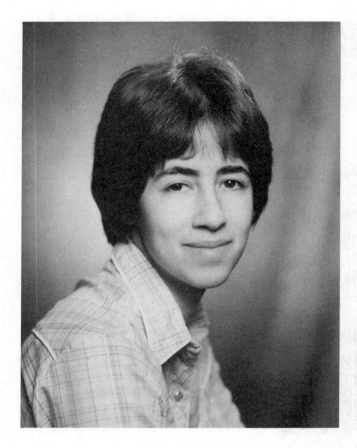

Figure 3.12
General illumination of the background
produces a halo effect around the subject's
body. The background lighting provides a
separation between the subject and the
background that gives the portrait a three-
dimensional appearance.

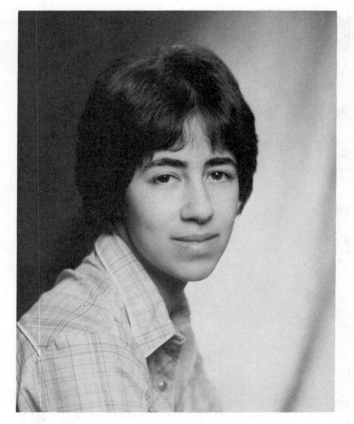

Figure 3.13
Illumination of the section of the background
toward which the subject is facing. Note how
your eyes are drawn to the subject's face.

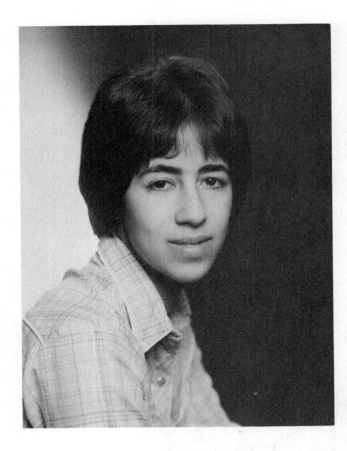

Figure 3.14
Illumination of a section of background
between the subject's back and the edge of the
background. The light part of the background
competes with the face for our attention.

toward the edges of the background (Figure 3.12).

2. In the second position we illuminate only a part of the background—the part between the subject's body and the edge of the background in the direction in which the model is facing. The other part of the background appears much darker by comparison (Figure 3.13).

3. In the third position we reverse the background light and illuminate the other side of the background, the side between the subject's back and the edge of the background (Figure 3.14).

Let us examine these three background lighting options carefully.

1. The halo-like effect is interesting. It provides good separation between subject and background. This lighting has a pleasant, three-dimensional look. It is a definite asset to the portrait.

2. This situation injects a new concept into our study of background lighting. By shining the light in the same direction that the subject is facing, we use the light to reinforce the feeling of motion in that direction. Our eyes are drawn to the area between the model's face and the edge of the background.

3. The third position is an incorrect and counterproductive use of background light. The bright part of the background between the model's back and the edge of the background tends to compete with the subject for our attention. It is as if we placed a bright primary color at the edge of the picture drawing our eyes away from the subject itself.

Another interesting lighting effect can be achieved by turning the reflector of the background light completely around so that it illuminates the back of the model's head. For certain hair styles, especially on

Figure 3.15
The background light is turned so that it shines through the subject's hair. Note that the background photographs dark.

females, the light shining through the hair adds a dramatic accent to the portrait (Figure 3.15). This system works especially well on bearded male subjects in profile. Since the light no longer shines on the background, the background will photograph fairly dark. This creates a nice contrast between the backlighting on the hair and the dark background.

These background lighting techniques should cover most portrait photography situations. With some practice you will feel comfortable enough to try slight variations on your own. Each of these lightings has a specific objective. Try to avoid random placement of lights. They can be distracting and inartistic. Make the background light work in your favor.

SPOTLIGHTS

A spotlight is a highly concentrated, narrow beam light source. It is a frequently used accent light, especially for hair illumination. Spotlights are also used on the face when additional highlights are needed. It is an ideal tool for hair lighting. It is usually positioned on a light stand that can be placed to either side of the subject, so that the light stand itself is not visible in the picture. Elevated slightly above the subject's head, it can be directed onto the hair.

The intensity of the hair lighting can be controlled by changing the height of the light or by moving the light stand itself. You should try to avoid having the light directed on the hair and spilling over onto the subject's face. Blonde and gray hair will require less light than brunette and black hair. You will be able to judge the proper light intensity visually. On dark hair it is almost impossible to make a serious lighting error. It is not at all critical. With light hair more care is required. Overlighting of blonde or gray hair will destroy the detail, making it look like a blob of light rather than the delicate texture of hair. If in doubt, always underlight.

A simple procedure to determine the proper level of hair illumination is as follows:

1. Direct the beam of light on the hair so that it does not overlap onto the face.

2. Vary the distance between the light and the head and observe its effect on the hair. Notice that the closer the light comes to the hair, the less visible the individual hair strands become. As you move the light away from the hair, the individual hair strands become easier to distinguish.

3. Gradually, increase the distance between the spotlight and the head until the individual hair strands become visible.

This is the position that will give the hair maximum brilliance without a loss of detail.

Spotlighting on the face itself can add brillance to a portrait. It should not be done in a random manner. To be effective the light placement must make sense. If possible it should relate to a lighting situation that might conceivably occur in our daily living. For example, a three-quarter view of a model's face can have spotlighting along the cheek line furthest away from the camera (Figure 3.16). This is not too different from a condition that could occur in your living room at dusk. Let us imagine a stream of daylight from the window mixing with the incandescent lighting in the room. A person seated with his back to the window would receive a similar lighting combination.

Another situation is in the lighting of profile poses (see also Chapter Ten, Profiles). A spotlight along the line of the profile resembles the lighting we see when a person faces the source of light such as a window or a sunset.

With this in mind, always try to justify the placement of the light. Avoid the use of haphazard spotlighting. The results are usually distracting. For the present it is best that you confine the use of the spotlight to the hair and the cheek line of your subject.

We have covered the use of main lights, fill-in lights, reflectors, background lights, and spotlights. They are the major tools of our craft. These lights are the building blocks for the proper illumination of a face. Of these building blocks, the most important is the main light which forms the foundation. It must be properly placed and capable of standing on its own. No amount of ornamentation by the other lights will compensate for its improper use.

You should not curb the temptation to experiment with lighting, but keep it

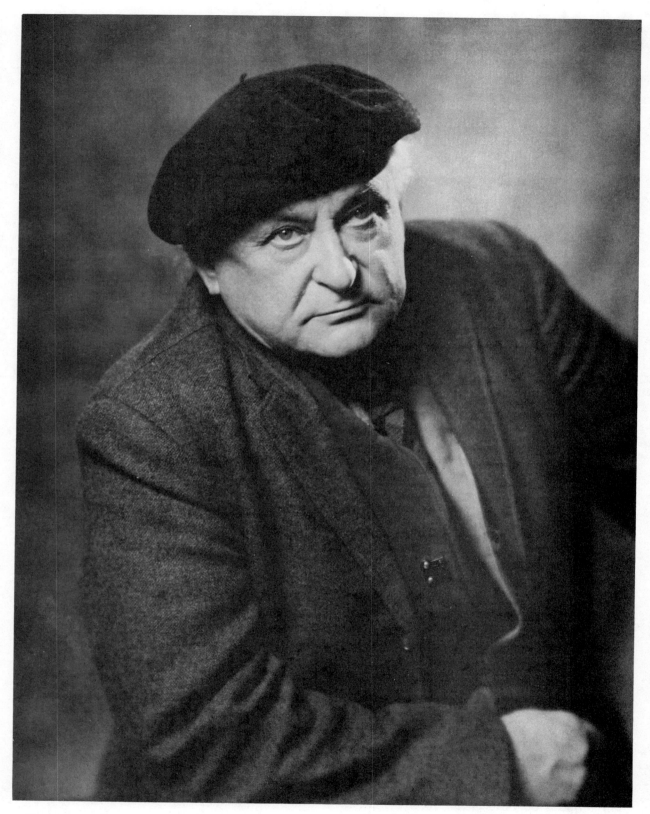

Figure 3.16
A spotlight accents the cheek line of sculptor Jacques Lipchitz.

purposeful. Regardless of what you do, the net result should be the enhancement of the subject's appearance. Keep in mind that lighting is only a part of the process of producing a good likeness. Do not lose your sense of proportion and make lighting an end in itself.

Good lighting is not a casual, random procedure dependent on the element of chance. As each additional light is added we must consider the purpose it will serve. If you cannot justify a light's use, turn it off. You are probably better off without it.

CHAPTER FOUR

The photo session

A<small>T THIS POINT IN OUR STUDY</small> we have acquired enough information to be able to stand behind a camera and attempt a simple photo session. It is best that this is done early in our education, before the volume of data becomes too complicated to sort out.

The preceding material will enable us to look at a subject with a more discerning eye. Many more factors are needed if we are to develop a sophisticated approach to

portrait photography. These will be discussed in subsequent chapters.

THE FEMALE MODEL

We have become familiar with some of the techniques used by the portrait photographer and are now ready to put them

to practical use. A female model will be our first subject for this photo session. Our model is directed to sit on a swivel chair with a low back. We begin with the information-gathering phase of the sitting. The model, our raw material, is studied, appraised, positioned, lighted, and animated. These prerequisites are necessary if the camera is to record a credible likeness on film. Random picture taking will not be considered.

We direct our model to slump forward a bit to achieve a proper head-torso relationship. Remember, erect posture and stiffness are not desirable. The torso should lean slightly forward with the head held high.

Our model is then asked to turn her body to the right and to the left. From each of these positions ask the model to turn only her head toward you and to look at you. You should be positioned

near the camera while making these observations. Study the subject carefully from each of these positions. Turn the subject several more times.

A pattern will begin to emerge. Certain body relationships, the built in programming of this person, will soon become evident. (See Chapter Two.) The head and shoulder relationship, the way in which the head leans toward a particular shoulder, should be kept in mind. If the subject is not too inhibited, the pattern develops quickly. It will almost always be the same for a particular position of the body.

With the model's body still turned away from the camera and her head facing the camera, ask her to tilt her head first toward one shoulder and then toward the other. As mentioned in Chapter Two, the female will usually look natural with the head tilted toward either shoulder, the lower or the higher one. If the model constantly tilts her head toward a particular shoulder, don't try to change it. This is part of her uniqueness and contributes to her likeness.

At this point the model is familiar to us, and we are ready to go on to the next phase. The next logical step is to study the face. Repeat the turning of the subject, but concentrate only on the face. Try to determine which side of the face looks fuller. Look at the eyes to see which one of the eyes looks more open. The position of the upper lids will usually determine how much of the eyes are visible. Check the nose for bumps and other irregularities. Based on this information we are ready to make some photographic decisions.

Even though many picture possibilities exist for a particular subject, you should always proceed on the assumption that you have only a single film to expose. This will sharpen your concentration and sensitize you to the subtle details that might otherwise go unnoticed. Try to resist the temptation of relying on a quantity of exposures for good results. It doesn't work.

For the purpose of this exercise, let us assume that there are good picture possibilities from either side of the face. We will take photographs of both sides of the face so that we will have a basis for comparison. Our objective will be to get the best possible likeness of each side of the face.

Having already gone through the preliminaries of appraising our subject, we ask her to once again turn her body to the right and to face the camera. Our next step is to properly position the main light. The elevation of the main light is determined by the position of the eye highlights. (Refer to Chapter Three.) We arrive at the proper height for the main light when the eye highlights position themselves just below the upper lids. The main light is then moved from one side to the other so that we may see its effects on the shape of the face. In this instance, because of the subject's hair and her relatively slim face, the main light on the front view of the face works well. Figures 4.1 through 4.5 were illuminated by a main light reflector, background light, and a hair light. Note the head-torso and head-eye relationship—also the location of the eye highlights.

Some sort of fill-in illumination is now needed to soften the shadow side of her face. A fill-in light is placed next to the camera, avoiding the introduction of any additional eye highlights. The background is now illuminated by a small background light, and a spotlight is added to make the hair more brilliant. The model is almost ready to be recorded on film. The only thing lacking is a characteristic expression.

We will pause here and look at our female model before continuing.

Figure 4.1
A three-quarter view with the main light on the broad side of the face. Note the head-eye relationship. The head is turned to the side as the eyes look at the camera lens.

Figure 4.2
The model's body is turned slightly more toward the camera resulting in an almost full-face view. Only one ear is visible. The subject's face looks somewhat slimmer than in Figure 4.1. The main light is directed at the broad side of her face.

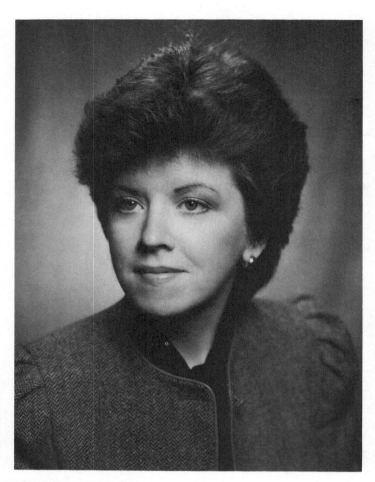

Figure 4.3
The subject's body faces the camera and the head is turned to a three-quarter view. The head and eyes are facing in the same direction. Main light illumination is on the broad side of the face.

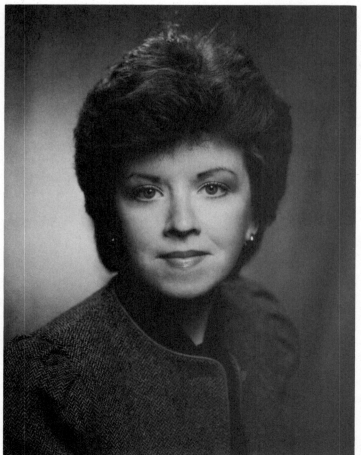

Figure 4.4
The model's body is turned a bit toward the left side while her head faces the camera lens. She is leaning forward from her waist and her head is slightly elevated to achieve a proper head-torso relationship. The main light is placed next to the camera so that it favors the left side of her face.

Figure 4.5
The subject's body is turned almost completely to the camera and her torso leans slightly forward toward the camera lens. The main light is moved slightly to the subject's right side, which makes her face look slimmer. Note how shifting the main light location changes the shape of the face as compared to Figure 4.4. This is the view preferred by the subject.

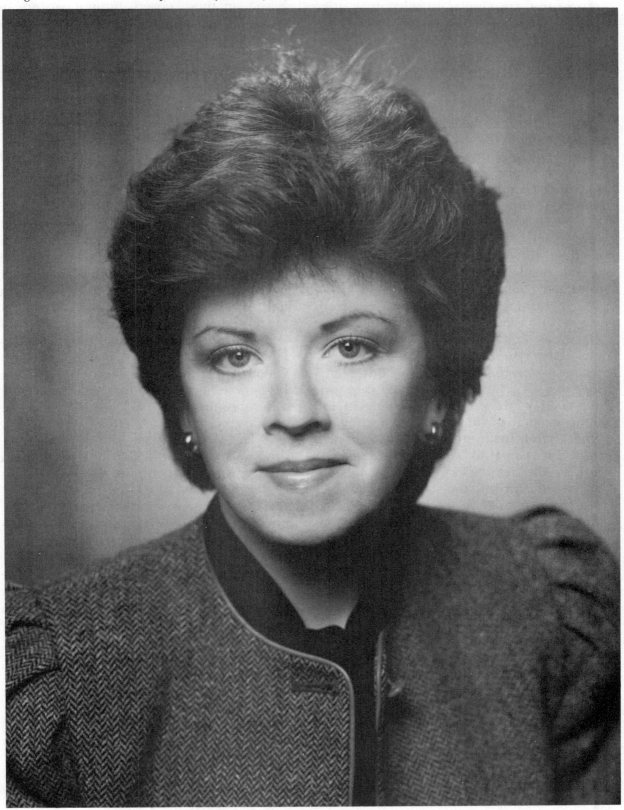

THE MALE MODEL

Most of the preliminary subject appraisal procedures are similar to what was done with our female model. Even though our male subject is entitled to equal time, duplication will be avoided where no purpose is served by the repetition. As before, we are seeking that certain uniqueness in our subject that distinguishes him from all others.

Our model is asked to turn his body to the right. With the body in this position, we request that the head be turned toward the camera. The same procedure is repeated with the model's body turned to his left. As with the female, we avoid erect posture by asking our model to lean slightly forward from the waist. The proper head-torso relationship is now established.

In turning the model back and forth as we did with the female subject, we make an interesting observation. His movements are not as fluid as those of the female. From the waist up his body seems to move as a unit. The female can turn her head while keeping her body in the same general position. The male, on the other hand, will most likely also move from the waist to accomplish a similar turn of the head. His head will probably tilt slightly toward the lower shoulder. If you suggest that he tilt his head toward the other shoulder he will generally look and feel uncomfortable. The male head and shoulder relationship often falls into place of its own accord. Gently guiding the subject helps encourage this. As you continue to appraise the male subject you become aware of another discernable difference in the way he moves his body. The turning radius of the head with the body in a fixed position is more restricted than that of the female. The model will look strained and unnatural if you try to increase this turning radius.

Our concentration is next directed to the model's face. We compare the sides of the face for fullness, eye size, and laugh lines. We look for bumps or other nose irregularities. The choices we make must be based on these observations if we are to produce a characteristic likeness. We continue to resist the ever-present temptation to take a quantity of random exposures instead of always aiming for the ultimate picture.

We are now ready to position the main light and once again we determine the elevation by eye highlight position. The highlights should ideally appear just below the upper lids. Moving the main light to either side of the model's face will result in a different facial shape for each light position. We make a decision and add a fill-in light to the shadow side of the face. As before, we try to avoid the additional eye highlights that could result from the improper placement of the fill-in light. Background lighting and a spotlight on the hair provide the finishing touches.

We must now give life to our subjects before recording their images on film. Credible expressions must be elicited. Proper subject animation will make the difference between a "so-so" snapshot and a good portrait likeness.

The photographer should stand behind the camera so that the view seen through the photographer's eyes is similar to the picture area covered by the camera. The camera is now the extension of the photographer's eyes, a third eye. A characteristic expression on our subject's face is needed to complete the scene.

Direct the subject to look into the camera lens and request a closed mouth smile, an open mouth smile, and a serious expression. These three possibilities with their slight variations usually cover the full range of expression possibilities. Compare the three to see which seems most appropriate for the model. For the most part we can rely on instinct to pick the most suitable expression.

There are some useful rules of thumb that should be used along with these in-

stincts. If a full smile causes the subject to squint too much, try a lesser smile. For closed mouth smiles try to avoid excessive lip pressure, which can result in a crooked smile or a smug look. Serious expressions sometimes make the subject appear to be staring. Asking the model to blink the eyes helps to overcome this problem.

You now zero in on the the subject by looking only at the face. The invisible strings you have woven can now be manipulated. You and the model are one. Subtleties that previously escaped you become obvious. You are in total control of the subject. What we have here is almost a form of hypnosis. You suggest expression changes that are almost imperceptible, but you see them and the model feels them and responds.

Your absolute concentration is needed to get the proper expression at the instant of picture taking. All the preparations in lighting, subject appraisal, and positioning are of limited value if you fail to get a characteristic expression from the subject at the final instant of film exposure. You end up with a statue rather than a likeness.

Having done this we are now ready to try some variations. Although we should always aim for the creation of the ultimate picture each time we click the shutter, it stands to reason that other good picture possibilities exist for the subject. Even if it is only to have a basis for comparison, these other picture possibilities should be explored.

With the subject in the same general position, try changes in expression. If your original choice was a closed mouth smile, try an open mouth smile or no smile at all. As you continue to animate the subject you will become increasingly sensitized to the person's expression range and capabilities. You will be able to distinguish between the characteristic and the artificial, stilted look. More often than not, you will find a single expression that personifies the subject best.

Additional variations can be tried by turning the model's head a bit in each direction. Note its effect on the shape of the face. Pay particular attention to the eyes. If the model's head is turned too much, the eyes will look strained. If this occurs consider having the model look at a point other than the camera lens. When making these changes always keep the eye-head relationship in mind.

This is a period of discovery. The information we acquire during this search for picture possibilities is cumulative. Our ability to make more intimate observations increases as we continue to observe our subject.

Up until now the main light position has not been changed. Try moving the main light to either side of the face. The result that occurs when the position of the main light is changed can be dramatic, especially if the light is moved from the broad side of the face to the narrow side.

Generally try to avoid too many variables at one time. It disturbs your concentration. If you decide to change the main light location, don't ask your subject to change position at the same time. It is best to study each individual variation before trying another.

Novice photographers have a tendency to use only attractive people as models. This is not a good idea. In many ways it is easier to get a good likeness of a less attractive subject.

With the not-so-beautiful people, shifts in camera angles and light locations will produce dramatic changes. Specific problems will become apparent, and you will be able to introduce specific corrective measures.

This is not so with the problem-free face. It is far more difficult to determine which side of a good looking person's face will make the best portrait. The chances are good that the person will look well from almost any angle. The ideal portrait might elude you. You are less likely to become proficient in portrait photography if

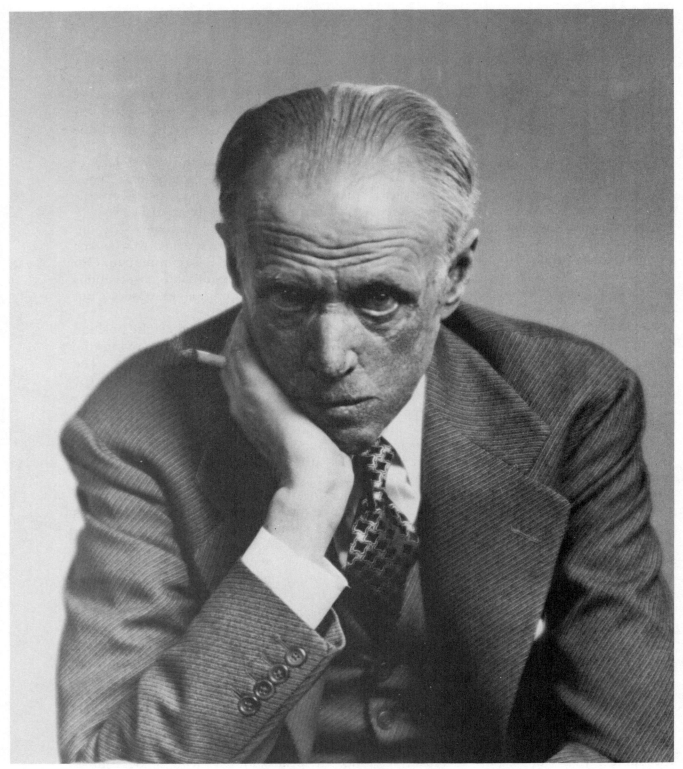

Figure 4.6
This portrait of Sinclair Lewis appeared on the book jacket of one
of his novels.

you limit yourself to only good camera subjects.

The goal of portrait photography is to give importance to our subjects even if they are visually undistinguished. Unlike the photo journalist who uses verbal description to identify the photograph, the portrait photographer is limited to the visual sense. Some people show their uniqueness by dressing in unusual color combinations and unconventional clothes. The subtler forms of likeness are more difficult to see. They include the subject's body programming and the almost limitless range of facial expressions peculiar to that person. When we finally see these subtleties they appear almost like mystical perceptions.

This intimate visual glimpse of the subject will rarely occur by accident. It requires the methodical study of the person based on the principles covered by this section of the book.

CHAPTER FIVE

Subject animation

IF WE EXAMINED ALL THE INGREDIENTS that go into the creation of a good portrait, a characteristic expression would probably be the most important. This characteristic expression is the most critical of all the factors that establish likeness in a portrait. The expression we elicit from our subject is what brings the portrait to life.

Like everything else in portrait photography, getting the proper animation for a particular person is not a lucky accident. There are a number of reliable guidelines that will head us in the right direction. These guidelines, along with our instincts, will make it possible for us to properly animate our subject.

Although the range of expression capability with its subtle variations is infinite for every person, it can generally be placed in three main categories: open-mouth smile, or laugh; closed-mouth

smile; and a non-smiling, or serious, expression.

These expressions can be perfectly natural when they occur in context, but they will usually feel wrong to the person facing a camera. There is little correlation between the way people think they look and the way they appear to others. Our mirror image is different from the way others perceive us. Because of this a person cannot be relied on to create an expression in its subtle form on the basis of the way it feels.

Even the professional model must be directed and cued. It is important to involve the model in what you are attempting to do. The subject's cooperation is essential for a good result.

Let us suppose that the subject usually smiles but tends to freeze up in front of a camera. Since a severe look is not at all characteristic, some way must be found

to cheer the model. Should you tell jokes or try to be funny? This is one of the few situations in portrait photography where a definite "no" is in order. Trying to be funny doesn't work and usually defeats the purpose. A smile elicited by a funny remark (on the remote chance that it is funny) is usually accompanied by closed eyes. A person in front of a camera facing a moment of truth is not receptive to jokes or other irrelevancies.

If we examine the anatomy of a smile we see a definite pattern in its formation. The lips make light contact before they part. This is followed by a narrowing or closing of the eyes. This sequence will almost always occur when a person responds to an amusing situation. Interestingly enough, a person who is asked to look less severe will respond by smiling

without the narrowing or closing of the eyes.

The following procedure will help elicit a characteristic expression: Ask your model to have the lips touch lightly and to gradually apply light pressure while attempting a smile. Encourage the subject to try to look less severe. Repeating this routine several times will usually result in a good expression. It is very difficult for someone to perform in front of a camera. Often the subject will protest and say, "I can't possibly do it." Your gentle persuasion will prove him or her wrong.

Sometimes you encounter a subject who smiles easily off camera but looks smug or sarcastic in a closed mouth smiling photograph. This problem can be handled quite easily. The smug look is caused by the laugh line on one side of the

Figure 5.1
The laugh line on the right side of the picture is more prominent than the one on the left. It is deeper and more horizontal in direction. This dissimilarity in the laugh lines becomes more apparent when the subject attempts a closed-mouth smile. The result is a smug expression.

Figure 5.2
An open-mouth smile minimizes the differences in the laugh lines, thereby eliminating the smug expression. Although his eyes look somewhat narrower with an open-mouth smile, this is the better choice for the subject.

Figure 5.3
The subject looks comfortable with a closed mouth smile. Her lips
make just enough light contact to keep them from looking
compressed. When smiles are elicited by direction rather than by
stimulus, the eyes usually remain wide open. (See Chapter Five.)
Note the effect of the background lighting. The brightness occurs
on the left side of the picture, the direction in which the subject
is facing. The viewer's eyes are drawn to her face, rather than to
the right side of the picture. (See Chapter Three.)

mouth being deeper and more horizontal in direction than the laugh line on the other side of the mouth. This is a fairly common occurrence (Figure 5.1).

A good way to soften this look is to ask the model to avoid pressure on the lips. Very light lip contact will often eliminate this problem. If it doesn't work, try photographing the other side of the face. This problem will almost never occur on both sides of the face. Generally, closed-mouth smiles look more natural when the lips are not too compressed.

Some subjects look more natural with open-mouth smiles. If they can laugh without closing their eyes, the result can be a very animated portrait (Figure 5.2). When photographing open-mouth smiles, try to avoid showing the lower teeth. This is more appropriate for a dental X-ray.

If the subject cannot get the lips to make contact easily because of a dental problem, a laughing picture will work best. Always avoid an expression that is obviously unnatural.

Serious expressions require delicate handling. Since they are less animated than smiles, they can look frozen and statuelike. If the subject has a tendency to stare, it will be more obvious in a non-smiling expression. Asking the subject to blink the eyes will often eliminate the stare. To properly utilize the blinking of the eyes, the model must be cued so that the eyes are not closed during the actual exposure. Explain the problem to the model and then try a few practice blinks by having the model blink on cue. It works best with single sharp, but gentle, blinks rather than a fluttering of the eyelids.

Regardless of which expression you select, asking the subject to moisten the lips helps eliminate a set look around the mouth. The purpose of moistening the lips is to create some movement around the mouth area. When you consider the limited available language to accomplish this relaxing of the mouth, asking the subject to moisten the lips is a good choice. Sometimes your subjects whose mouths are usually dry will attempt to use their fingers when they can't muster up enough moisture with their tongues. Just explain the reason and assure them that the lip moisture is not the purpose.

At the final moment of picture taking you will gain more cooperation from your subject if you follow a predictable pattern. Before each exposure ask the subject to moisten his lips and blink his eyes. The subject senses this repetition and subconsciously waits for these cues. Subtleties in expression that are otherwise almost imperceptible emerge through this method.

In summation, if you want a credible recording of your subjects: Don't tell jokes, have them moisten their lips and blink their eyes, pay particular attention to lip pressure, and never, ever ask them to say, "cheese."

CHAPTER SIX

The female subject

A FEMALE SUBJECT CAN PROVIDE an almost unlimited range of portrait possibilities. She can vary her hair style, make radical changes in her attire, and use make-up. She can do all of these things and still stay within the style criteria of the period. She is a multifaceted subject. Despite this potential for variety, portrait photography can produce a good likeness for each set of conditions.

CLOTHING

Within these choices there are practical matters to be considered. If a particular dress is highly stylized, it might soon become passé. Unless there are reasons for dating the portrait, avoid extremes in clothing.

In head and shoulder portraits, the

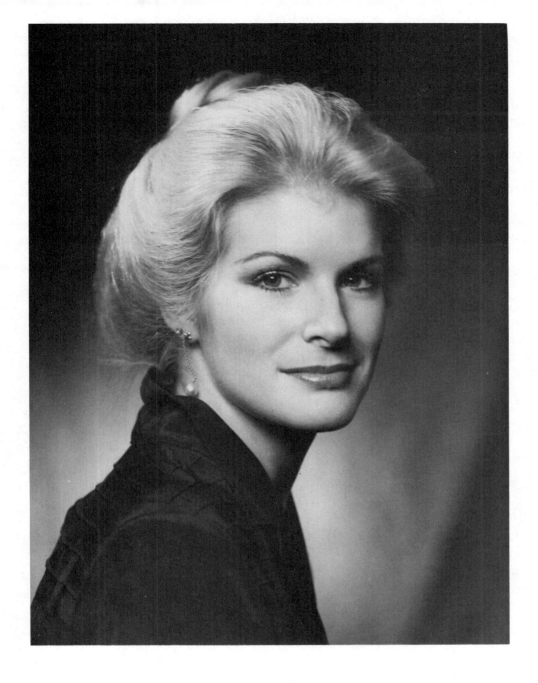

neckline is a particularly important consideration. The neckline is, in a sense, the pedestal upon which the head is mounted for viewing. It should not compete with the face for attention. For the most part, vee, jewel, and mandarin necklines work out very well. Vee necklines give length to a face. Square necklines, where the collar bones are visible, can sometimes look unsightly in bust portraits. With older people, the higher necklines help conceal wrinkles and sagging skin.

Turtle necks can cause problems, especially with darker colors. The higher camera elevations used in bust portraits tend to foreshorten the neck. Since very little neck is visible, the portrait looks as if a head were mounted directly on the shoulders without the neck being present. Cowl necklines do not have this problem.

Where appropriate, bare shoulders can give a glamorous air to a close-up portrait.

Sleeveless garments can be a problem in head and shoulder portraits where the lower part of an arm is visible. A bare arm near the bottom of the picture tends to divert the viewer's attention. In three-quarter length portraits, the arms are not as obvious. In general, heavy people should not be photographed in sleeveless outfits.

When sheer blouses are worn, under-garments become more visible under the bright photographic lights.

Solid colors present fewer difficulties than designs and stripes. (Clothing colors are also covered in Chapter Eleven, Color.) Close-up portraits can give patterns a prominence far beyond what was intended by the wearer.

If in doubt, suggest several costume changes. There is, however, an inherent danger whenever you photograph a person with changes in clothing. It is virtually impossible to take a set of photographs with one dress and then duplicate the facial expression while she wears another dress. This can lead to a situation in which the subject prefers the head in one portrait and the costume in another, and it is difficult to switch heads.

If standing three-quarter length poses are to be made in addition to the seated head and shoulder portraits, it is best to do the three-quarter shots first. The clothing will remain wrinkle free longer when the subject is not sitting down.

Regardless of the subject's attire, the photographer must always think in terms of a female subject. With the increase of women in the professions and industry, more blazers, suits, and clothing generally associated with the male are being worn. Although there are not strict fashion rules, there is a subconscious (but unjustified) tendency to give a masculine association to these styles. This association should not influence the manner in which you pose and light the subject. Even in this less traditional role, the first priority is to portray her as a women. She is sure to appreciate it.

MAKE-UP

Everyday make-up will work out well for most subjects in black and white portraits. In color photography, since the camera sees what the eye sees, we have to pay more attention to the make-up. Avoid excessive use of powder when softening skin sheen and oiliness. Too much powder will give the skin a dull appearance. Rouge must be blended carefully or it will look blotchy.

Unless done by a professional make-up artist, it is best to confine the lipstick to the lips only, rather than to try to paint in a new lip line.

With make-up, less is better than more.

GLASSES

Tinted glasses worn for cosmetic purposes often look different in a photograph, especially in color. They tend to obscure the brilliance of the eyes, and generally look much darker than expected. There is also the problem of the lenses imparting their hue to the areas adjacent to the eyes. If the subject has other glasses, try a few exposures with clear lenses. It is best to have a basis for comparison. Don't be too surprised if your model goes back to wearing clear lenses after she sees the proofs.

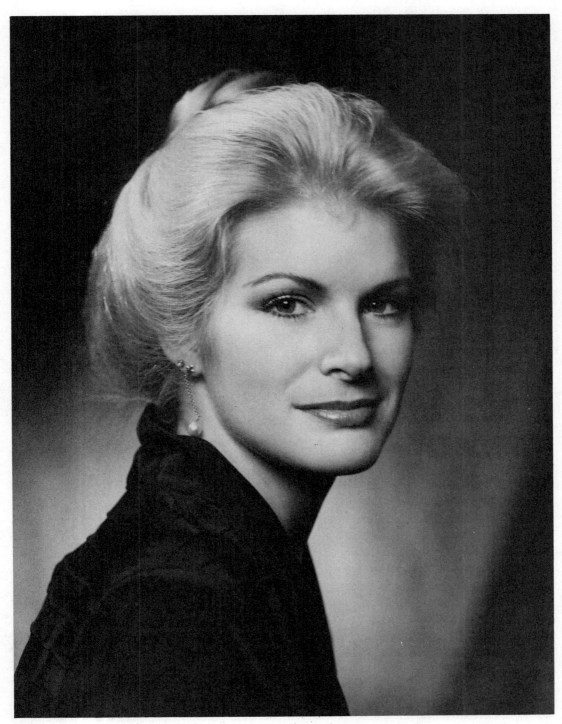

Figures 6.1a and b
Although the likeness is retained, different hair styles can produce dramatic changes in a portrait. Note the delicacy of the hair lighting. The blond hair retains its luster without a loss of detail. Delicate hair lighting accents the textures that would be lost by overlighting. Note the tilt of the subject's head toward her higher shoulder. The pearl jewelry is an excellent choice.

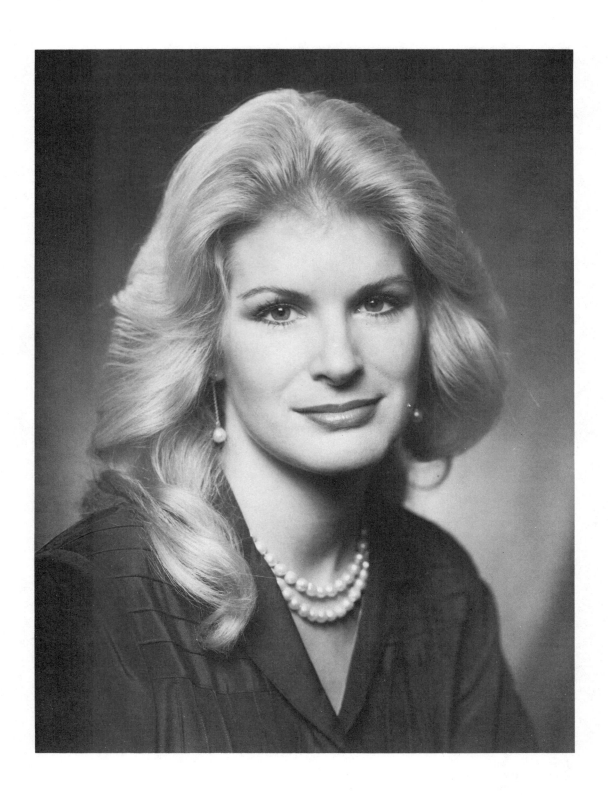

HAIR

Women's portraits lend themselves to striking hair lightings. You can be quite generous with the amount of light you use on dark hair without destroying the texture by overillumination. (See Chapter Three.) Blond and gray hair require more delicate treatment. A good way to determine the proper illumination level is to vary the distance between the light and the hair. The hair looks like a blob of white when the spotlight is very close to the head. As you move the light away, the detail in the individual hair strands becomes more visible. The point at which you can see a separation between the hair strands is usually correct.

The range of acceptability is fairly wide, but it is best to stay on the conservative side. The lower light levels will show greater detail, thereby giving the hair a softer look.

As mentioned earlier, the intensity of the light on the hair must be judged visually. There is no practical way to measure it. Hair styles with tight curls look better if the hair lighting is somewhat subdued. You might try placing the background light directly behind the subject's head with the reflector turned around so that the light shines through the hair. This is a dramatic way to light blond hair or hair where there is some separation between the strands. This can be done in conjunction with the usual hair lighting where the light is positioned above the model's head.

The female subject can provide further variety to her photographic image by quickly changing her hair style. Hair that is worn loosely can be combed into an upsweep for a more formal look. If time and the subject's patience permit, you should expose negatives of all the hair styles she usually wears (Figure 6.1a and b).

Loosely worn hair is in a sense a face-saving device. By moving the hair at the side of the face either forward or back, you can control the shape of the face. The more forward the hair, the narrower the face. You can make a heavy face thinner and more triangulated by adjusting the hair. It is one of the most effective means we have for flattering a subject in a completely natural way.

When photographing women with upswept hair, the exposed ears can appear quite prominent. A woman who photographs well full face with loose hair that covers her ears might have to be turned slightly with an upswept hair comb. The three-quarter view of the face showing only one ear will usually take care of the situation.

If the subject plans to visit a hairdresser before the sitting, she should avoid a completely new hair-do. It is usually best to stay with a familiar hair style.

JEWELRY

Jewelry should be chosen with care. An overabundance of jewelry is not desirable. In head and shoulder portraits avoid the use of more than a single strand or necklace. Some of the strands can be mistaken for lines or wrinkles on the neck. It is almost impossible to get them to look straight. A necklace must be carefully adjusted each time the model turns her body, so that it continues to look centered.

Dangling earrings require attention. Even when the subject is perfectly still, the earrings continue to swing like miniature pendulums. With slow shutter speeds the earrings often look blurred.

Pins and brooches can look like white

blobs if the light strikes them at the wrong angle. They should be tilted away from the light to keep the reflection at a minimum. You can end up with a reasonable facsimile if you pay attention to the highlights on the jewelry. For the most part, jewelry will not look the way it does in a slick advertisement, nor is it necessary or desirable. It should not be the center of attention.

LIGHTING

Each good portrait lighting has an equivalent lighting situation that appears naturally in our everyday living. As mentioned in Chapter Three, we must justify the use of every light if the result is to make any sense. One such lighting is extremely flattering to the younger woman. It makes use of a phenomenon that occurs when a person laughs or smiles vigorously. The eyes seem to take on a brilliance that gives rise to expressions such as, "Her eyes are shining," or "The eyes are smiling." During laughter, the eyes become more watery. It is the reflection from these tears that gives the shining look to the eyes. The tears usually settle on the edge of the lower eyelids where they pick up the reflections that result in a more brilliant look of the eyes.

This look in the eyes can be simulated with photographic lighting. The object is to place small highlights in the eyes so that they appear just above the lower eyelids, similar in position to where they occur naturally. The lighting is very simple. A bare light bulb, 25 to 100 watts, resting on the floor in front of the model, is all that is needed. Since it is the image of the light bulb itself that is being reflected, the color or tone of the floor is of no consequence. Care must be taken not to damage the floor with the heat of the

exposed light bulb. Reflections from the bulb will show up just above the lower lids similar to where they usually appear. The subject's smile will be enhanced by these reflections. We can make the subject's eyes shine at our command.

This technique is used as a supplement to the regular lighting and not as a substitute. The bare light bulb should be lit only after the lighting set-up for the model has been established. It can cause confusion if it is left on during the preliminary exploration of the subject's face. There is an additional fringe benefit to this lighting. It gives brilliant gleaming highlights to the teeth (Plates 10, 11, 12, and 13).

It is not advisable to use this lighting for older women subjects. The bare bulb lighting from below gives unnecessary attention to sagging skin and wrinkles in the neck area.

BACKGROUND

You can make variations by using different background tones. Light hair and fair skin against a white background can produce a delicate high-key portrait in both black and white and in color. If your subject wears a white blouse and is photographed through a soft focus lens, the results can look ethereal. (See Chapter Fifteen.)

An entirely different mood can be created by photographing the same subject against a black background. Pay particular attention to the hair illumination. Properly balanced hair lighting is very striking against darker backgrounds. Try not to get carried away by overlighting. These background variations can also be tried with dark-haired women. They work well both in black and white and in color.

More detailed information on back-

grounds can be found in Chapters Eleven and Fifteen.

The ingredients that give the subject her likeness are very fragile. Most are contained in the space between the mouth and the eyebrows. For photographic purposes this area of the face is the basic person. We depend on it to provide her with identification. This basic likeness can be used for an infinite variety of portraits depending on how she chooses her attire, hair style, jewelry, and make-up. The portrait photographer complements these choices by using compatible poses, lightings, and backgrounds.

Despite the number of ways in which the subject and the photographer ornament this basic likeness, she still retains her identification.

She is a great camera subject.

CHAPTER SEVEN

The male subject

IF WE WERE TO SPECIALIZE IN MEN'S POR-
TRAITURE, we would develop an acute sensitivity to the photographic problems that are related to the photography of male subjects. Although some photographic techniques are common to most portrait subjects, the approach used in the creation of a "man-of-distinction" type portrait will be different from the one used to photograph a child.

Let us imagine a male subject sitting in front of our camera. We have gone through the preliminaries of studying him for good picture possibilities. His left side seems like an excellent choice except for his hair, which looks quite thin from this angle. If we examine the other side of his face, the hair is much fuller but his nose looks crooked. Which of the problems is the greater liability? Would he prefer a crooked nose to a bald head? For the most part, male subjects with thinning hair ex-

press concern over the way it will photograph. This concern seems to take priority over the more important aspects of their likeness. On the other hand, the objective viewer is hardly aware of this man's hairline. This is a fairly common situation. Because of this the male subject's preference will often differ from the general consensus.

Fortunately, there are practical ways of coping with this type of situation. The photographer need not trade a high forehead for a crooked nose. All that is needed is a way to deemphasize the hairline. A head screen works wonders on male foreheads. A head screen is nothing more than a small shade that is placed between the main light and the man's forehead. (See Chapter Fifteen.) The shade reduces the level of illumination in that area. The forehead photographs darker and no longer competes with the rest of

the face for attention. The viewer becomes less aware of the thinning hair. Although this treatment will usually suffice, it can be carried a step further. The background light should be kept low so that the area of the background behind the head remains dark. The shaded forehead blends with the subdued background. This diverts the viewer's attention from the hairline. We have effectively camouflaged the bald spot without in any way changing our subject's likeness.

We now go from poverty to riches. If a man needs a haircut, it should be done several days before the sitting. Too recent a haircut gives an unattractive, shorn look.

Your subject should select appropriate clothing and not wear something that is completely out of character. For a fairly formal coat and tie sitting, solid-color pastel shirts are good. A white shirt will do for a black and white, but in color it is almost impossible to avoid a slight pastel hue. As a rule, very dark colored shirts do not go well with neckties. They usually look better when the collar is worn open. Stripes can cause problems since they rarely look straight. A shirt collar that is too snug will make the neck bulge.

Avoid suits and ties with large patterns. Seersucker suits often come out looking like pajamas. The coat will fit better if the subject empties his pockets. Look out for lint and wrinkles especially with darker colors. Dandruff on the shoulders of a dark suit can be a disaster. The subject is usually aware of a dandruff problem, but might not realize how noticeable it is in a photograph. Don't ignore it for fear of embarrassing the person. You could say, "Photographic lighting makes almost imperceptible lint and dust spots very prominent. It would be a good idea to run a whisk broom over the shoulders." With casual attire avoid an overly conspicuous design. It tends to compete with the face for the viewer's attention. This is especially so when shooting in color.

Be aware of the need for good grooming. If the man is wearing a jacket, try to keep the back from bunching up. The shirt collar should be slightly higher than the jacket collar. The edge of the shirt cuff showing beneath the jacket sleeve is a perfect frame for the wrist and hand. A wrinkled vest on a seated subject looks like an accordion. Opening some of the bottom buttons and pulling the ends down usually helps.

Neckties need special attention. Due to camera perspective problems, even a slightly off-center tie looks messy in a photograph. Especially in three-quarter or side views, the part of the shirt that is usually covered by the tie is visible. The camera sees the side or back of the tie and the buttons on the shirt. Keeping the tie close to the body avoids this. Bow ties, because they do not cover the front of the shirt, can make the shirt look blousey. Be sure to have the shirt pulled down and tucked in.

Set the hour of the sitting for a time when the subject is most likely to be at his best. "Five o'clock shadow" and fatigue are difficult to hide from the camera.

Avoid crossing the knees when shooting head and shoulder portraits. It tends to bring the torso too far forward. This projection of the torso can make the head look out of proportion to the shoulders.

Informal poses work out well for most male subjects. An excellent one is to have the man straddle a chair while resting his arms on its back. The proper head-torso relationship is immediately established by his leaning forward onto the chair back. It feels very comfortable and looks natural and unposed.

A variation of this position is to have the subject stand while resting his hands or arms on the back of a chair. The height of the chair back should be able to accommodate the subject's arms without his slouching or stretching. You can, however, have him lean forward from the

waist and lean on the chair back with his arms folded. Familiarize yourself with the available chairs. Try them out for size. It saves time and indecision when you are positioning a model. The subject's confidence in you will not waver when you act in a deliberate manner.

Sunburn can cause photographic problems. Since makeup is rarely used in male portraits, blotting the subject's face with a tissue helps to cut down on the oiliness and perspiration that usually accompany sunburn. The strong highlights caused by sunburn can otherwise make the face look swollen. If the skin is peeling, reschedule the photography for another time.

If the subject asks to be photographed holding a pipe or a cigarette (which often looks trite), don't let him light it. The smoke will give him a halo. Even if the halo is deserved, the portrait will not benefit from the smoke screen.

Bearded males make excellent profile subjects (see Chapter Ten, Profiles). They lend themselves to dramatic lightings and are relatively easy to do. For a striking profile lighting, turn the background light around so that it illuminates the side of the profile that is not visible from the camera position. The result will be a rim of light around the edges of the beard. Since the background light is being used to illuminate the face, the background will photograph darker. A darkened background is an effective setting for a profile lit in this manner.

Even if you don't plan to specialize in men's photography, it makes good sense to be familiar with its specific problems. We should try to avoid the stereotype male portrait that only vaguely resembles the subject. The portrait of a man running for office should be different from that of a professional boxer. Yet each type of subject requires its own brand of dignity. Try to accommodate to each subject's personality and background.

Make each subject his own "man of distinction."

Children

MANY CONTEMPORARY OIL PAINTINGS OF CHILDREN are done in the classic manner. This traditional treatment gives an air of importance to the portraits. In the photographic medium a similar sense of dignity can be given to the subject.

The photographer enjoys a certain advantage over the painter. A camera can record whole ranges of children's facial expressions, each of which is a particular facet of the child. On the other hand, there is also the temptation of continuously exposing film in search of the ultimate picture.

The photographer should not depend on expression alone to create the portrait. It is easy to become captivated by an uninhibited child and to lose sight of the other ingredients that are needed to produce a good likeness. Unlike a snapshot,

whose charm is almost completely dependent on the child's expression, a portrait should provide likeness in greater depth. The expression itself should not be its only redeeming feature.

We will concern ourselves with portraits of children who are old enough to accept direction. We will not place our reliance on "catch-as-catch-can" photography. Except for some modification, the techniques used in children's portraiture are not that different from those used with adults. The flexibility is somewhat greater because masculine and feminine body stances have not yet firmly established themselves. Head tilts on young boys will show a fluidity not present in most adults. Poses that might be called cute in a child's portrait would probably look silly for an adult.

We must also be careful not to make the portrait too formal. A child desiring to

comply with the photographer's directions can effect awkward, exaggerated stances.

In children's portraiture, some of the usual concerns about the sides of the face are not as important as they are with adults. A good expression will often compensate for minor differences in the sides of the face.

LIGHTING

For younger children, an overall type of illumination is preferred. An overall rather than a specific lighting will permit you to make changes in the child's body positions without an accompanying shift of the lights. Although incandescent lights can be used, strobes are a better choice. A main light and a fill-in placed slightly further back from the subject than usual will provide a soft, even illumination to the picture-taking area.

By keeping the lighting simple, more attention can be given to the actual photography. With general illumination, the natural highlights on a child's face will provide adequate brilliance to the skin.

Hair lighting can be added by the use of a spotlight from above. Try to avoid having the hair light spill over onto the child's face. A spotlight shining on the nose makes it look enlarged and bulbous. The background lighting should be kept simple.

For older children, the lighting can be similar to that used for adults. When selecting lighting for children, the photographers should maintain a sense of proportion. Do not sacrifice good picture possibilities because you are too involved with the effort of getting an ideal lighting. The less you fuss with the lighting, the more time there is to cope with the often unpredictable child.

BODY POSITIONS

Full-face poses are excellent for children, especially when they look directly into the camera lens. With three-quarter view positions, an "eyes-on-camera" pose can sometimes look strained. It is often best to have the subject look in the direction in which the head is turned. Profile poses work out extremely well for most children. (See Chapter Ten.) In addition to the more conventional profiles, try some with the head tilted up. The upward tilt of the head provides additional animation to the portrait. Profiles with the head tilted downward make dramatic and thoughtful-looking poses. The eyes, although lowered, should remain open. If the situation permits, some of the striking lighting discussed in Chapter Ten can be attempted. Profiles can lend an air of formality to a child's portrait without giving it a feeling of stiffness.

A table is an excellent prop for younger children. Pay particular attention to the height of the table. (See shoulder slope in Chapter Nine, Hands.) An object that holds the child's interest can be placed on the table. This can be a book, a toy, or a musical instrument. If the object is familiar to the child, the hands will fall into a natural position of their own accord. When a young child responds to a photographer's direction, it is usually in an exaggerated manner. Keeping the child captivated by an object on the table helps to relieve some of the tenseness between the photographer and the child.

CLOTHING

Pay attention to the grooming of young children, expecially boys wearing blazers. Jackets rarely fit well in sitting positions.

Figure 8.1
A natural smile and the missing teeth add a certain amount of charm to the portrait.

Informal wear does not require as much care since it is judged by less rigid standards. Frilly dresses can make young girls look too bosomy in sitting positions. Try to avoid wrinkles and the bunching up of the dress around the waist and bodice. Large image sizes can overcome some of these difficulties. By zeroing in on the head and showing less of the body you reduce the chances of messy clothing ruining an otherwise good portrait.

Girl's hair requires special attention. Long hair poses a problem when it falls on the shoulders and the strands separate. A messy look can be avoided by brushing the hair away from the shoulders.

Dental braces and acne are some of the less attractive manifestations of adolescence. The photographer should not be discouraged by them. They can be deemphasized with sensible handling.

Dental braces can cause difficulties if you try to conceal them. It is best to accept their existence and not try to hide them by having the child's lips maintain contact. It will only call attention to the child's discomfort.

Don't try to conceal missing teeth by asking the child to apply pressure to the lips. It never looks natural.

Keep in mind the advantage that a profile has in concealing braces and missing teeth. This is probably the easiest and most effective form of concealment (Figures 8.1 and 8.2).

Figure 8.2
A profile view conceals the teeth and gives the portrait a more formal appearance.

Pimples and acne are a frequent fact of life in children's portraiture. You can think of these skin problems as a stage in the child's development and ignore their existence. Some subjects and parents are apt to feel otherwise. There is no simple solution to minimizing these blemishes. Make-up is one alternative. It must be done carefully and only on specific blemishes so that a mask effect is avoided. For professional photographers there is an additional caution to observe. Photographers run the risk of being held liable if the child has an adverse reaction to the make-up. You should insist that a parent or other person apply the make-up to avoid being placed in jeopardy. Negative and print retouching is another alternative. This will be discussed later.

CUEING

In their desire to follow direction, children will often make faces when asked for a particular expression. Cueing directions must be specific and given in easily understood language. They should be accompanied by gestures, especially when the requests involve subtle changes in poses and expression.

Try to keep parents out of the picture-taking area. If you cannot avoid it, insist that they remain in the background and not try to assist you. Parents tend to divide the child's attention. Although they have good intentions, their presence usually is counterproductive.

In children's photography a good expression has a much higher priority than it has for adult portrait subjects. With children who are difficult to control a good expression will often save the day.

The span of attention for children is usually limited, so speed is of the essence.

Get as many pictures as you can early in the sitting. You may not have the same opportunities later in the session. Comprehensive subject evaluations are often impractical. As the sitting progresses, you will be able to gauge the degree of control that you maintain over the child.

The quality standards for children's photography have been eroded by the availability of low-priced, mass-produced photographs. They offer good value and fill a definite need. This type of photograph has the high degree of sameness you would expect in a large-volume, low-priced product. Unfortunately, people are being conditioned to accept this essentially impersonal product as the standard for children's portrait photography.

A good portrait of a child is a composite of many factors. Children, like adults, are programmed and are likely to respond in a particular way to a particular situation. Facial expression has a high priority. The result can be enhanced by following portrait procedures that are modified to accommodate to the needs of children. We must be prepared to observe subtle nuances, such as the way a child cocks his head or moves his body. Reject any poses that look less than comfortable.

Children's photography can be either a complete delight or an exhausting experience, depending on the age and temperament of the subject. It would be nice if we could exercise total control over the child. A good part of the time the photographer is forced to settle for less.

Flexibility is the key to good children's portraiture. Since it is difficult to predict the degree of control we will have over a child, it makes sense to have a list of photographic options at our finger tips. There is little time for contemplation in a child's photo session. If conditions permit, go for the total portrait. If you have to settle for less, a minimum requirement is a characteristic expression.

CHAPTER NINE

Hands

E XCEPT FOR THE FACE, the hands are the most animated parts of the body. They have their own way of expressing themselves. They respond to changes in mood and reflect emotions by the way the fingers position themselves. The limp hand or the clenched fist is usually related to a particular state of mind or facial expression. The hands often betray the tenseness that the subject feels. Hand gestures and finger positions complement and enhance the intensity of these facial expressions.

Visually and for the purposes of portrait photography, the hands and the face respond to stimuli as a unit. When the hands are included in a portrait, this correlation between hands and face should be maintained. We are unlikely to see a person with a clenched fist laughing, but

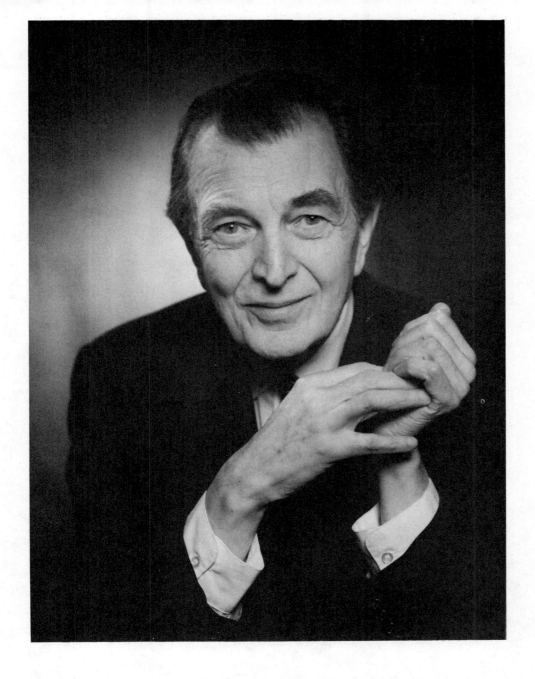

those clenched fists could be just the right accompaniment for a non-smiling determined expression.

Since most people facing the camera are somewhat inhibited, natural looking hand positions are unlikely to occur of their own accord. Good hand photography requires the same delicacy and care that is given to photography of the face.

Let us zero in on the hands themselves as subjects for photography. We will concentrate on getting esthetically pleasing hand positions without the use of props. A photograph of an open hand without any curling of the fingers looks almost clinical in nature. As we curl the fingers, the hand begins to look more natural. In context the hand is rarely seen in the open flat position. A tight fist should also be avoided. Comfortable looking

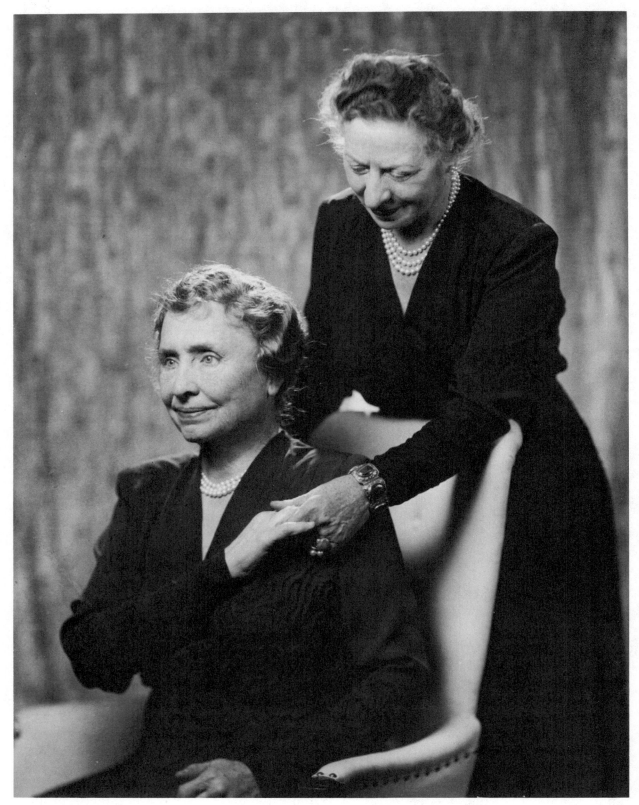

Figure 9.1
Helen Keller communicates with her companion through hand
contact. Note how spotlighting the knuckles draws the viewer's eyes
to the fingers.

Figure 9.2
Alice Neel uses all her fingers to hold the gloves; yet they do not look clutched. A profile view of the knuckles shows just enough of the hand to keep it from dominating the portrait.

hand positions can be achieved by having the person form a loose fist and then extend the forefinger slightly. The forefinger should not extend too far or it will look like a pointer.

The angle at which the hands are presented to the camera is extremely important. Side or profile views are the most attractive. The front view will show more of the fingers, which can make the hands look unnecessarily large and out of proportion.

If the subject's hands are an important part of his or her identification, a spotlight can be directed across the line of the knuckles for additional impact. Portraits of pianists, sculptors and others whose hands are a part of their craft benefit from this technique (see Figure 9.1).

Interlocking fingers should be avoided since they generally resemble bunches of bananas. Clasping the hands is a better way to achieve a similar effect.

PROPS

When props are used, the treatment of hands is somewhat different. We will start by sitting at a table. Place a pencil on the table and then pick it up for the purpose of writing. You probably used your thumb and forefinger to grasp the pencil. If a pair of eyeglasses are handy, place them on the table and then pick them up. In addition to the thumb and forefinger, you had need for an additional finger to support the glasses. Do the same with a book placed on the table. Still more fingers were required to lift and support the weight of the book. In each instance the size of the object and its weight determined which part of the hand was used. If the entire hand were used to pick up the pencil or just two fingers were used to hold the book, it would look wrong. Generally, the manner in which an object is

Figure 9.3
In this portrait of Louise Nevelson the hands are introduced and kept on the same plane as the face. Perspective distortion is minimal. Note the way in which the glasses are held.

held in the hand is directly related to its size and weight.

A good way to utilize the hands in a portrait is to have the person hold an item that is in some way related to his life style (see Figure 9.2). Let us suppose that the model is a musician and the object is a flute. Instead of placing the flute in your subject's hands, ask him to lift it from the table. Having the person do this by himself will usually result in natural looking hand positions. Had you placed the flute in his hands, it might have had a contrived look. By keeping in mind the proper relationship between the size of the item and the way the hand grasps it, you will avoid an artificial appearance.

This is a good device for photographing someone who wears eyeglasses only part of the time. Having the subject hold the glasses establishes their association with that person. If the subject looks better without wearing the glasses, you end up with a more flattering portrait without losing the likeness (Figure 9.3).

Another way of including hands in a portrait is to use folded arms. People usually fold their arms in a particular way. (See body programming in Chapter Two.) If they attempt to reverse the way the arms are folded, they tend to look and feel awkward. Because people facing a camera are self-conscious, you might not get the natural folded arms position on the first attempt. Ask the model to do it both ways. You will be able to see the difference at once.

A table is a good prop for folded arm portraits. The height of the table is very important. Torso and arm lengths vary too much for any single table height to serve for every model. As a rule, if the

subject feels comfortable, the table height is probably correct. The photographer can also check the slope of the shoulders (the angle formed by the neck and the shoulders). The angle should be similar to the way it would be if the subject's hands were resting in his lap rather than on a table top. If the shoulders appear too high, place a cushion on the chair to raise the body.

It is usually impractical to change the table height. Too low is better than too high. If the table seems a bit low, ask the subject to lean forward. The portrait will benefit in two ways. Leaning forward onto the table top will bring the head forward so that it is almost on the same plane with the hands. Keeping the hands and the face on the same plane will minimize perspective distortion. The other benefit is that an active head-torso relationship will result from the body leaning forward from the waist with the head in the erect position. This gives an animated feeling to the portrait.

Even though the arms are folded, you still have to pay attention to the hand positions. The hand nearest the camera is usually the problem. It should either grasp the other arm or rest on the table in a loosely curled position with the forefinger slightly extended.

Holding the hands up to the face can give an unposed look to a portrait. It must be done carefully to avoid a trite appearance. The secret ingredient for a hand-to-face portrait is the utilization of the subject's own body programming.

When seated at the table and left to their own devices, people will often lean on their hands or bring their hands up to their faces. The chances are good that each of the positions they assume will be duplicated if they sit at the same table at a future time. If you take advantage of this body programming an additional part of the person's identification and likeness can be incorporated into the portrait.

Poses that occur of their own accord produce the most meaningful results.

You can begin by directing the model to lean on the table. Make sure that the table is at a comfortable height by checking the slope of the subject's shoulders. Ask the subjects if they ever put their hands up to their face, and if the answer is yes (it usually is), ask them to try it. This will be the start of a period of fumbling and indecision. Nothing that the subject does will feel natural. Because it is not being done in context, the subject finds it awkward to fall into a comfortable pose. Request some variations. For example, if she leans on her left hand, ask her to try it with the other hand. Go back and forth several times. A definite pattern will begin to emerge.

The repetition of a particular position is your clue to what is natural for the subject in this setting. If you guide your model in this manner, natural body programming will usually surface (see Figure 9.4).

Many variations of a single hand-to-face pose are possible by changing camera angles and elevations. If your first choice is a frontal view with the subject's eyes looking into the camera lens, try a three-quarter view or a profile.

In hand-to-face poses, make sure that the subject doesn't lean too heavily on his or her hand. Excessive pressure on the face tends to distort the features. If the model rests his chin in clasped hands, it is important for the wrists to remain rigid. A bent wrist looks wilted when the hands are clasped together.

Chair backs make good props for hand poses, especially if the male subject straddles the chair and rests his arms on the chair back. As long as the height relationships are correct, almost any piece of furniture can be used as a prop for hand poses.

When hands are included in a portrait they cannot be treated casually. If

Figure 9.4
Ned Rorem struck this characteristic pose during the sitting. Note
the spotlighting of the fingers.

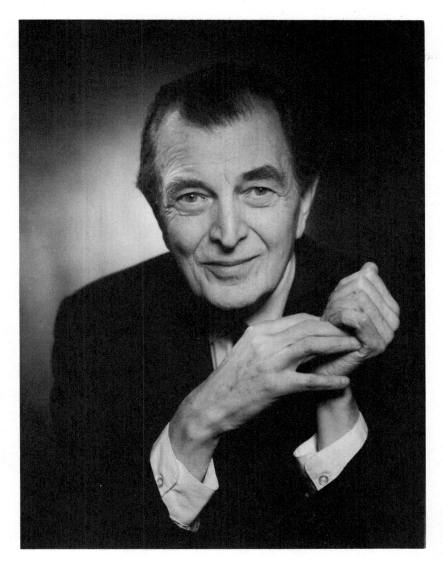

Figure 9.5
Alexander Tcherepnin rests his hands in a comfortable pose. The emphasis is on the knuckles.

they are to complement the portrait, the subject needs your experience and guidance.

Most portrait photography that includes the hands will fall into the following categories:

1. The hand by itself in a loose curled position.
2. The hand holding an item related to the subject's activity.
3. The hand making contact with the face.

The subject's built-in body programming will assist you in making the proper choice.

You can avoid some of the pitfalls of hand photography by following a few simple rules:

1. Try to keep hands on the same plane with the face.
2. Avoid interlocking fingers.
3. Favor the side or profile view of the hand when practical.

Including a person's hand can have a positive effect on a portrait. The subject will feel comfortable leaning on a table. This added comfort will make it easier for you to elicit a characteristic expression (see Figure 9.5).

Don't be afraid to include the subject's hands. Properly done, it can add another dimension to the portrait.

Never say, "Hands off!"

CHAPTER TEN

Profiles

Nothing is more encouraging to the novice portrait photographer than seeing spectacular results early in his or her education. Profile portraits can provide this impact with a relatively limited amount of photographic "know-how." They can be dramatic and pictorially exciting. Interesting and eye catching lightings can be used effectively even by the novice photographer. They need not be as subtle as frontal portraits, which require greater delicacy in handling.

In profile photography, unlike portraits where both sides of the face are visible, facial expression is a relatively minor factor. The emphasis is more on head-shoulder-torso relationships and interesting lightings.

The prevailing belief seems to be that unless the nose is near to perfection, one should not photograph a profile view. This is utter nonsense. Unless the profile is grotesque, good picture possibilities do exist. Profiles add another dimension of

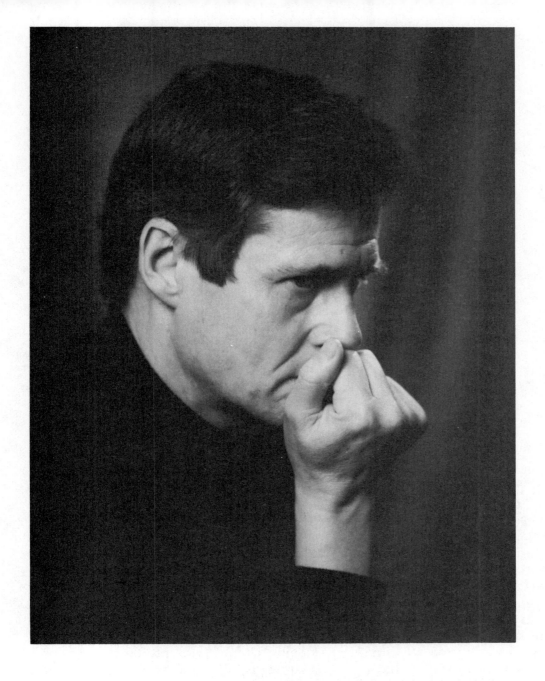

likeness and identification to a person. Keep profile possibilities in mind when studying the subject.

BODY POSITIONING

The problems relating to body positioning are not too different from those covered in Chapter Two, Subject Appraisal. A composite relationship between head and torso can be achieved in two ways. The first way is to have the subject turn her body away from the camera so that the entire body now presents a profile view. At this point the body is in a profile mug shot position which looks stiff, awkward, and generally uninteresting. We remedy this condition the way we did previously in Chapter Two, by asking the subject to slump slightly and to raise her head. The composite of a torso and head is once again a reality (Figure 10.1).

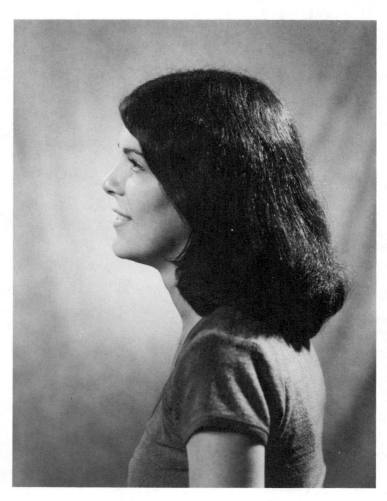

Figure 10.1
The subject's body and face present a profile view. Her torso leans slightly forward and her head is elevated. Only a small portion of the neck is visible.

The second method of creating the composite relationship between head and torso involves a concept not previously mentioned. We ask the subject to turn her body toward us so that she faces us and the camera in a conversational position. The subject is then directed to turn her head away from the camera so that only the head is in the profile position. The rest of her body continues to face us. Once again we have created a composite effect between head and torso, but this time the composite involves a difference in direction between torso and head. The body continues to face us while the head is in the profile position (Figure 10.2).

The result we see could have occurred in context in the following hypothetical set of circumstances:

The subject is engaged in a conversation with you when suddenly someone shouts, "Hey you!" from the side of the room, causing the subject to turn her head in that direction. The result is the body forward and the head in profile. It is a very natural looking composite of head and torso and is not apt to look contrived.

Now that we have two ways of positioning a model for profile photography, you have to decide which is best for a particular subject. You should try both combinations before making your photographic decision. The details you should look for are the following: In the first position the neck receives far less emphasis and attention. This is a handy device to deemphasize a neck that is full and unsightly. If the subject's neck is attractive, the second position might be a better choice. The second position can also be used to give an illusion of length to a neck that would otherwise appear to be short. The two positions are really variations of the same thing, both of which

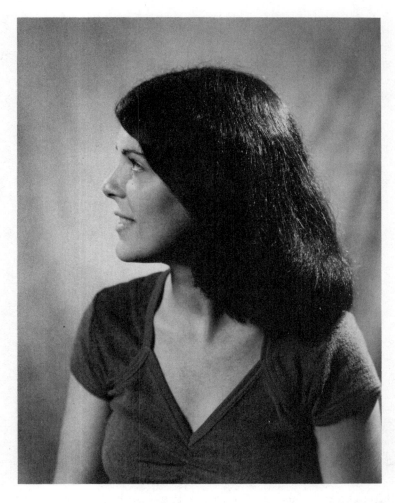

Figure 10.2
The subject's body faces the camera and her head is turned to a profile position. More of the subject's neck is visible than in Figure 10.1.

should be tried. You will probably be successful either way.

LIGHTING THE PROFILE

Many exciting lighting variations can be used in profile photography. Unlike most other forms of portrait photography, subtlety is not a virtue. When we illuminate a profile we can let ourselves go, providing we stay with a few of the basic rules of lighting.

Let us start with our subject seated in the profile position with torso and head in the same direction. We will place the main light near the camera so that it illuminates the broad side of the face (the side with the visible ear). The height of

the main light will be determined by looking for the proper eye highlight location. It should be noted, however, that from a profile view the eye highlights are not always visible to the photographer. If they are not visible, do the following:

1. Position the main light as you would for a nonprofile pose.
2. Adjust the main light elevation so that the eye highlights are located just below the upper lid.
3. Return the adjusted main light to its original position next to the camera. (Refer also to the section on eye highlights in Chapter Three.)

The main light provides a good general illumination, but this lighting by itself is not very exciting. There is no particular emphasis on the facial outline of the model. Almost equal attention is shared by all parts of the face, with no part being

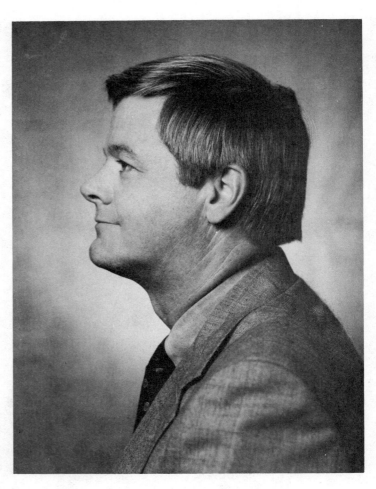

Figure 10.3
A profile view with the head and body
facing in the same direction. The main light
illuminates the broad side of the face. The
lighting is uninteresting and gives a flat
appearance to the face.

particularly dominant (Figure 10.3). The
general main light illumination is like a
first coat of paint. It serves as the base
over which the ornamental lighting
needed to emphasize the profile is added.

Ornamental profile lighting can be
effectively introduced by directing a spot-
light along the nose and forehead line.
The spotlight should be positioned two to
three feet above the subject's head level
and slightly closer to the background.
From this location it will be possible to
outline the profile with spotlighting. A
line of light on the nose and forehead
lends an entirely new dimension to the
portrait (Figure 10.4). The profile has be-
gun to assume shape and solidity. With
the lights in this position (main light on
broad side of face, spotlight on forehead-
nose line), an infinite variety of lightings
is available to the photographer.

By increasing or decreasing the
amount of light on the broad side of the

face, we control the emphasis along the
nose-forehead line where the light re-
mains constant. For example, reducing the
main light illumination level will make the
spotlighting along the line of the profile
more prominent. An easy way to vary the
intensity of the main light illumination is
to turn the light to the side or to move it
further back. The changes are very appar-
ent to the eye. Each change of the main
light illumination level produces a varia-
tion that can go from fairly subtle to very
dramatic.

With our model still in the same po-
sition we can try another lighting com-
bination. The main light is now placed to
the profile side so that it shines directly
on the face. The height of the lamp re-
mains the same. Unlike the single frontal
light without spotlight in the prior exer-
cise, we see a profile that has a bas-relief
and sculptured appearance. This type of
lighting is much more three-dimensional

86

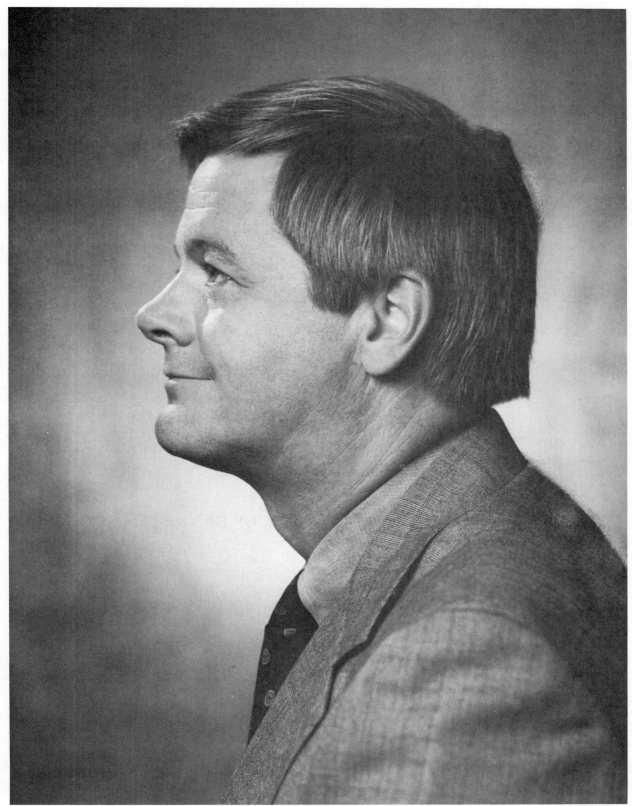

Figure 10.4
The main light is in the same position as in Figure 10.3, but a spotlight has been added to the profile. The portrait now assumes a three-dimensional appearance. The spotlight introduces additional planes to the face.

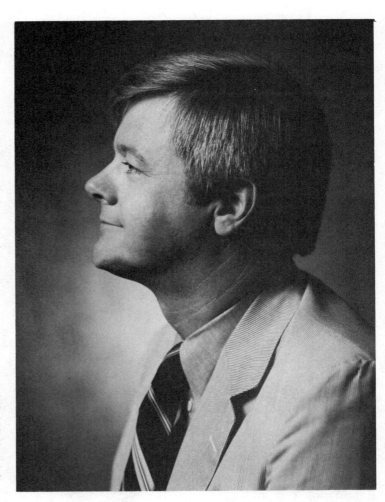

Figure 10.5
The main light now shines directly on the subject's profile. The viewer's eyes are drawn to the profile while the emphasis on the rest of the face and neck is diminished. This type of lighting can stand on its own without further lighting ornamentation. The face looks three-dimensional.

(Figure 10.5). Again we can vary the main light intensity and produce infinite variations of tone. If we desire a more striking profile, we can add a spotlight to the line of the profile and thus gild the lily (Figures 10.6a, b, and c).

The same combinations of lighting can now be tried in the other profile position (torso facing camera with the head in profile (see Figure 10.2). In this position we must be wary of a possible unsightly neck when the main light is on the broad side of the face. Should this occur, moving the main light to the profile side will help remedy the problem.

As mentioned earlier, you need not be subtle in the lighting of profile subjects. They lend themselves to all sorts of interesting lightings. Profiles can be further enhanced by adding hair and background lighting. (See Chapter Three.)

USE OF HANDS

Profile photography need not be limited to just head and shoulder portraits. The hands can be introduced in many interesting ways. If the subject's hands form an integral part of his or her likeness (such as a craftsperson, artist, or musician), their inclusion is desirable. As with any portrait where the hands are included we should try to use the same techniques in hand and finger placement. It is important to keep the hands on the same plane as the face whenever possible. This will help avoid a distorted perspective and overly large hands and fingers.

In some instances the hands can be brought up to the face. A great deal of care must be exercised when the hands are used in this way. Unless the subject

88

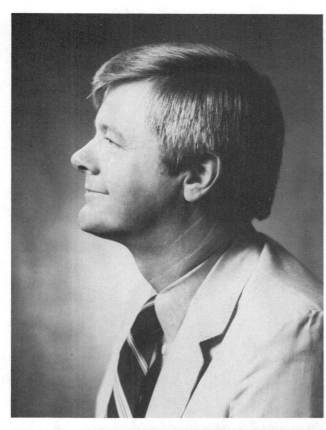

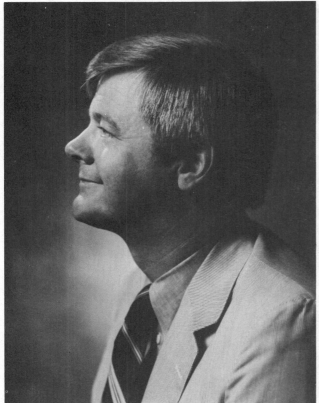

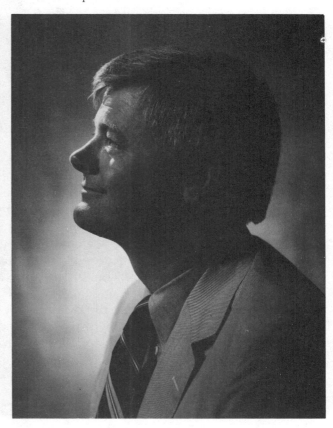

Figures 10.6a, b, and c
A spotlight is added to the profile and the main light intensity is gradually reduced. Many variations on this theme are possible. The background is kept dark to lend more drama to the portrait.

Figure 10.7
A pensive mood is created by the lowered head position and the downward look.

does this as a programmed posture the result can look trite. Try to think of your subject in a nonphotographic situation sitting this way of his own accord. If the subject looks comfortable and natural, the positioning of the subject will pass the test and you can be reasonably sure of a good result.

For variety you can try different eye and head elevations. Experiment by asking the model to raise and lower the head. You can also have the subject lower the head while looking downward (Figures 10.7 and 10.8).

We must not forget that at the final picture-taking moment the subject must be cued and animated. It would be a pity to end up with a human statue after going through all this trouble. Since only one side of the face is visible, a broad range of expressions are possible without the usual problems of squinting eyes and distorted laugh lines.

The portrait photographer is accustomed to hearing people say, "I don't look well in profile." More often than not you can present them with a pleasant surprise by proving them wrong. Even though the profile portrait isn't suitable for everyone, it should always be considered as a picture possibility. The results can be spectacular.

If I had only a single film at my disposal, I would use it on a profile.

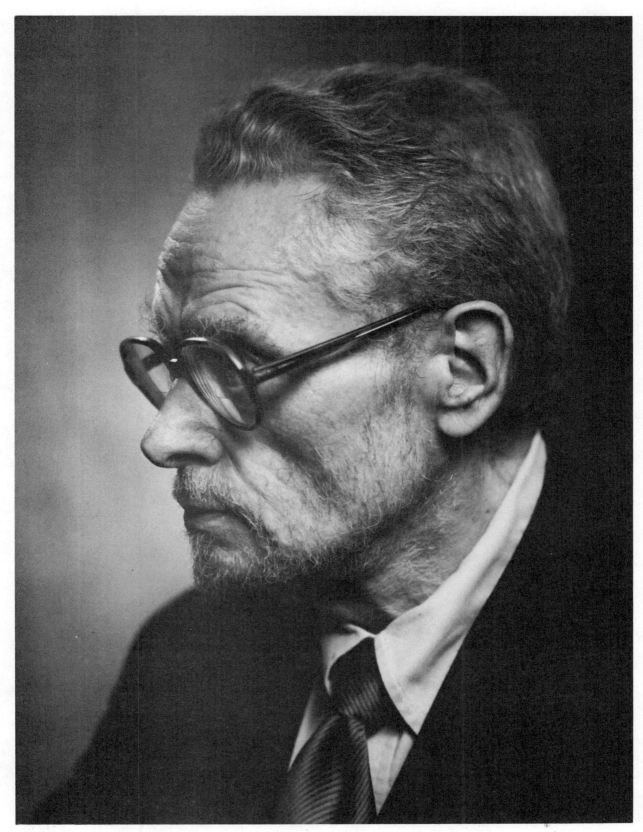

Figure 10.8
A portrait of Tony Smith. Note the slight lowering of the head.

Color

Wᴇ ᴀʀᴇ sᴜʀʀᴏᴜɴᴅᴇᴅ ʙʏ ᴄᴏʟᴏʀ. It would look strange if the people in these surroundings were seen only in tones of black and white. Before the advent of color photography, we were conditioned to accept black and white photographs as natural looking. To a large extent this feeling still exists. As long as the subject's likeness is retained, almost any range of black and white skin tones can be used without changing the person's likeness.

Color photography should be considered in a different dimension. Because of the realism of color, the artistic merit of a portrait is subjected to a harsher judgment by the reviewer. Perfect color fidelity is not necessarily a virtue. The skin can sometimes look too clinical and be better suited to medical photography. It would be more accurate to use the term "direct color" rather than natural color.

Adjustments in skin tones are easily made during the color printing process.

As long as the likeness is not changed, there is no harm in improving the subject's complexion. A considerable range of skin tone variation is possible while still maintaining a comparison between the subject and the portrait. If the change in skin color is not too extreme, we are able to accept it as a form of realism. A warmer skin tone will often be more flattering to the subject. This is especially true when the photograph is taken during the winter months.

LIGHTING

Lighting techniques for color are practically the same as they are for black and white. One exception is the background illumination. If you expect the background color to be fairly accurate, you must illuminate it at the same level as the subject's face. As a practical matter it usually doesn't make a great deal of difference if

the color of the background varies somewhat from the original.

Generally, with few exceptions, the mixing of different light sources is not recommended. The results are often unpredictable. One of these exceptions is the spotlight used for hair illumination. A slight yellowish cast can be used to warm up the color of the hair. Strobes and daylight illumination are also compatible. Good color portraits can be taken with any of the usual light sources, such as strobe, incandescents, or daylight. If you plan to use any unorthodox light mixture, you should experiment first.

FILM

Color portraits can be taken on color negative material or on slides. Portrait photographers are more likely to prefer working from color negatives. The negative positive system offers a great deal of flexibility and control. Many color variations can be made during the processing. The exposure latitude is somewhat greater than that of color slide material. Slight errors of exposure are easily corrected.

In the event that a color slide is needed, an excellent transparency can be made from a color negative. Color corrections can be incorporated into the slide in the same way as they are done on a paper print.

Slide film is a convenient medium when the final product is to be a color slide. Color slide film requires accurate exposures for good color rendition. It is far less forgiving to exposure error than negative material. Although color changes can be made and exposure errors corrected, they can be costly and time consuming. If you exercise reasonable care, you can get excellent results. Good quality color prints can also be made from slides.

Regardless of which type of material you use, it is essential that the film you select is balanced for your particular light source. The wrong film can result in unacceptable color aberrations. Always check the film manufacturer's recommendations.

Satisfactory black and white prints can be made from color negatives and slides.

BACKGROUNDS

Backgrounds for color portraits should be selected carefully. In studio settings, cool pastel shades are suitable for most subjects. The skin photographs at its best against fairly light shades of gray with subtle tints of blue or green.

Women and children with blond hair look especially well against white backgrounds (Plates 18, 19, and 20). As mentioned earlier more than the usual amount of light is needed to make a white background photograph white. If a white background is underlit, it will photograph in unpredictable pastel shades. It will require at least two to three times the amount of background lighting you would normally use with black and white film. Excessive lighting is equally troublesome. Reflections from an over-illuminated background into the camera lens can lower the picture contrast. You should experiment with different light levels to arrive at a good balance.

Some variations in the background color shades can be made by placing color filters over the background light. Acetate color filters usually used in color printing work well in this application.

The same principles should be applied to environmental settings. To take maximum advantage of the uniqueness of the subject's coloring, we must not overpower the skin tone with a background of vibrant color.

Outdoor settings are often easier to

use than indoor backgrounds. Colors in a natural setting always seem to go well together. We have been conditioned to accept a broad spectrum of color in a single outdoor setting as long as these colors exist in a natural state. Unlike a studio background, the scene itself can become important. It is an importance that is shared with the subject, still allowing the subject to be the center of interest.

CLOTHING

The face is the center of interest. Our perception of the skin color is affected by the colors around and near the face. For example, a woman with a sallow complexion will benefit from wearing a blouse of a cool color such as blue or green. The cool color will bring out the almost non-existing warmth of the sallow skin. A bright pink blouse, on the other hand, would totally eliminate the subtle presence of color in the skin.

Ruddy complexions are also enhanced by the use of cool colors near the face. Pink works best with very fair skin. White is usually safe for any skin tone. It can be very dramatic against dark complexions. Dark skin tones will show up well against shades of orange, red, yellow, and lavender.

On some occasions the color of the clothing will reflect onto the subject's face. A person dressed in green might end up with a green cast to the skin. Similarly a person wearing red could be red-faced without any provocation. The chin and neck areas are frequently affected by these color reflections. They can be minimized by shifting the main light position. Some color reflections will remain, but they will not be objectionable.

Large patterns and splashes of color tend to compete with the face for our attention. Avoid them whenever possible.

In portraiture the main emphasis is always on the color of the subject's skin. The clothing very rarely shows good color accuracy. Most of the time we are unaware of any discrepancy in the color. The differences are more apparent in light pastel shades and in white. If more accuracy is required, it is safer to use deeper and more saturated colors. You should never expect a perfect color match.

Most people have definite color preferences. The way they dress and the colors they use form a part of their likeness. You should try to utilize these colors to their best advantage and refrain from imposing your own preferences on the subject. It is best not to suggest radical color changes.

Extra care must be exercised in the way clothing fits. Wrinkles and the bunching of fabric are more visible than in black and white photographs. Corrections by retouching, although possible, are not completely satisfactory. They are expensive and usually look retouched, and the corrections sometimes look worse than the original defect.

The subject, if pleased with the result, will subconsciously begin to identify with the portrait. After a number of years the time factor becomes diffused, and the subject tends to think of himself or herself as a living facsimile of the portrait that was taken several years ago. The illusion harms no one. If we are to keep from breaking the spell, the clothing should not be highly stylized. Color fads in clothing can also create an almost instant feeling of obsolescence.

ACCESSORIES

Accessories should be selected with the same care as clothing. Each object adds a shade of color. In a bust color portrait, more so than in black and white, an in-

conspicuous hair barrette or tiepin can assume a prominence beyond what was intended.

Be alert to jacket lapel pins that have only temporary interest. For example, an election campaign button might be inappropriate, unless you happen to be the candidate.

As a general rule, avoid the use of any accessory that does not make a positive contribution to the portrait.

MAKE-UP

Normal daytime make-up will serve for most female subjects. In color photography the make-up should be extended to the neck and arm areas for skin tone consistency. Skin blemishes require special attention. The make-up should be carefully blended, especially near the hair line. Women with serious skin problems are naturally concerned with the way they will photograph. They are often reluctant to have their pictures taken. When they decide to sit for a portrait, it is usually for an important occasion.

When the appointment is being made, the prospective subject usually expresses her concern to the photographer. You can suggest that the judicious use of make-up is desirable. You should also explain that a loss of likeness might occur if the make-up is applied excessively. Since attitudes concerning people's perceptions of themselves vary, this can be a touchy subject. It requires some delicacy of approach. You might also suggest the services of a professional make-up artist and then leave the decision to the subject. She might prefer her new image, even if there is a change of likeness. (Also refer to make-up in Chapter Five, Women.)

Male subjects rarely require make-up. A slight skin blemish can be disguised, but do not spread the material too far into the adjacent areas. It will alter the skin texture. Although make-up is used on male subjects in commercial photography and television, we are unaccustomed to seeing make-up in an everyday context. A cleanly shaven face will usually be sufficient.

An important requirement for a successful color portrait is a pleasing skin color. Regardless of how well you handle the posting and lighting, the result will be unsatisfactory if the complexion tone is not good. The subject's likeness can be maintained without being clinically graphic. If you feel that the subject's appearance will benefit from a warmer flesh tone, by all means try to accomplish the skin color change. As mentioned earlier in this chapter, the negative-positive color system has a flexibility that makes variations of complexion tone possible.

WALL HANGINGS

Large color prints make attractive wall decorations. Properly framed and hung, they have a definite character of their own. Color portrait photographs should not be thought of as pseudo—oil paintings. We can, however, derive certain time-tested ideas from studying fine oil portraits. For example, in an oil portrait of a bust, the head is approximately life-size. If the portrait includes more of the subject's body, the canvas size is increased. In this way the near life-size proportion is maintained. Regardless of how much of the subject's body is included, life-size proportions give the portrait importance. Through conditioning we tend to apply the same criteria to photographic portraits. Although not always applicable, oil portrait techniques can serve as useful guides.

Viewing conditions vary a great deal. A portrait viewed under daylight-type fluorescent lighting will look entirely different from the same portrait illuminated by warmer incandescent light bulbs. For some situations, the addition of a picture light over the frame can be used to enhance the color.

Portraitists who learn to work in color without prior experience in black and white enjoy a certain advantage in this medium. Color becomes their primary language and there is a certain purity in their approach. They are unencumbered by a past experience in black and white in which color is converted to monotones. The photographer who first learns to work in black and white sometimes thinks of color as a second language. Until becoming comfortable with color, he or she subconsciously thinks in black and white and converts to color in the same way that we translate a foreign language. It takes a bit of practice to become photographically bilingual.

The photographer's objective should be the preservation of the subject's likeness. Absolute color fidelity is not one of the requirements. Any reasonable enhancement of the person's skin color will improve the portrait without a loss of identification.

Don't strive for absolute color. The subject is not a clinical specimen.

CHAPTER TWELVE

Location

A LOCATION PHOTO SESSION gives the photographer an opportunity to add another dimension to a person's likeness. In a customary environment, the familiar surroundings provide a relaxed atmosphere for the subject. The photographer, on the other hand, is on unfamiliar ground. Every location photo session requires some improvisation. This is especially so if the existing room settings are to be used. Each setting presents a different challenge. The photographer's experience and visual instincts are required to adapt his or her style and equipment to each situation.

You can think of the formal studio setting, with its limited number of backgrounds, as the textbook situation. We now have to apply our knowledge under more varied conditions. The principles are the same. Most of the conditions encountered are variations on situations covered in the previous chapters of the book. Our objective is to portray a subject in har-

mony with the setting. We will cover a series of common types of surroundings and the problems that are associated with them.

Looking at a setting for the first time and trying to decide where to place the subject can be a bewildering experience. None of the choices will seem ideal if you think only in terms of studio conditions. The first order of business is to select a location that has sufficient space to allow for the proper use of the equipment. The most exquisite setting is useless if there isn't enough room to place the camera and lights.

The photographer must never forget that the center of interest in a portrait is the subject and not the surrounding. The subjects should not blend with the background nor should the background overwhelm them. For example, a woman dressed in a floral pattern and surrounded by plants will look like an attempt at camouflage. A more solid looking background

would be a better choice. Common sense and experience will help you to strike a proper balance.

Lighting a portrait subject in an unfamiliar location can be confusing. In large rooms you will find that the lights appear to be dimmer than they are in your usual studio setting. If you are far from a wall or if the ceiling is high, you do not benefit from their reflective surfaces. Dark colors in a room will also contribute to the apparent dimness of the light. This can result in the photographer losing orientation. There is a tendency to think that something has gone wrong with the equipment.

Utilization of the existing lighting, if it is attractive, helps to preserve the character of a setting. The mixing of photographic lighting with the room illumination requires careful planning. If the overall lighting of the room is from floor lamps and ceiling fixtures, incandescents will blend better than strobes. The integrity of the setting will be preserved. Strobes tend to overpower the existing illumination and impart a character of their own.

If possible, keep the room lighting off while you position your photographic lights. The existing lights can be distracting and confusing. Make your lighting decisions before turning the room lights on again. With room lights on you will usually see a pleasant blending of the two types of lighting. It will be especially apparent in the hair and clothing. The existing lighting will in a very natural way help provide the illumination that you would usually get from a reflector or a fill-in light. There are two cautions to be observed:

1. Watch out for multiple eye highlights.
2. Avoid ceiling lights on the heads of males with thinning hair.

The mixing of daylight with photographic lights is more complicated. Even with lots of experience it is easy to become confused when the two are combined. Because of the different qualities of the lights it is difficult to judge the individual intensities accurately. Strobe lights mix well with daylight, but they must be used carefully. Color film that is balanced for strobes is also suitable for daylight. A proper relationship between the two types of light sources must be maintained to assure a realistic appearance. The strobe light should not cancel the daylight effect.

It is usually simpler to confine the lighting to a single type of illumination. However, this should not be done at the expense of the artistic possibilities that might result from the mixing of light sources. Mixing light presents a challenge and an element of uncertainty. If time permits, the photographer can also try some alternative lightings. The additional exposures can serve as a back-up if the original judgment was faulty.

During daylight hours a window can be used as a primary light source or main light. The lighting on the subject's face will have a familiar traditional look. Photographers and portrait painters have long favored the use of window light. Additional fill-in lighting from a reflector is usually needed to remove the harshness from the shadow side of the face. A reflector will redirect a part of the window illumination to where it is needed. Place the reflector on the shadow side of the face and then move it a bit in each direction. Each position of the reflector will produce a different change in the shadow side of the face. The reflector enables you to lighten the shadow in a subtle way. There is a possibility of getting unwanted reflections in the subject's eyes if the reflector is moved to a frontal position facing the subject. The image of the reflector itself can be picked up by the eyes, resulting in an unnatural glare in the eyes. This might go undetected during the photo session and show up later as an unpleasant surprise.

In large rooms with darkly colored walls and furnishings that do not provide adequate reflected light, supplementary lighting may be needed to properly light the subject's clothing. For three-quarter and full length poses, spotlights from the sides can be used to outline the figure. If the subject is dressed in dark colors, the effect can be striking.

An archway makes a good background. A subject framed in an archway takes on a three-dimensional appearance. Objects in a room as seen through this opening can be backlighted so that they draw the eyes through a series of layers to produce a stereo effect.

A variation is using this setting without backlighting. The result would be a dark background framed by a somewhat lighter archway. It lends itself to all sorts of interesting possibilities. Let your imagination run wild. The subject need not be centered and can be positioned in any part of the archway opening. Full length poses with the subject leaning against the opening are good possibilities. Standing or seated, head and shoulder or full length, this setting will easily accommodate the many possible variations. If an archway is not available, you can consider using a doorway.

An attractive window makes an excellent prop. As with an archway, it provides a natural frame for the portrait. Semitransparent curtains are helpful for concealing the panes of glass and eliminating unwanted reflections. Venetian blinds and drapes with prominent patterns should be avoided. During daylight hours the lighting on the subject's face must be intense enough to balance the strong backlight from the window. If the lighting on the face is not strong enough, you will end up with a semisilhouette effect. This silhouette effect, however, can be striking in a profile pose (Plate 15). An attractive view from the window can serve as a background (Plate 16). The balance of the illumination between the light on the subject and the outdoor background is an important consideration. Careful exposure meter readings should be taken of both the subject and the background. A loss in detail either in the subject or the background will result if the lighting is not in balance.

After dark the subject can be positioned in front of the curtained window and lit with artificial light. A window seat is another possibility. The window frame can form an enclosure for a subject sitting on a window seat.

A fireplace makes a pleasing background. If the fire is not lit, you can place a bare light bulb in the fireplace to provide a cheerful, realistic glow. It usually looks better than the real thing.

All location photography requires a certain amount of improvisation and imagination. There are, however, times when none of the available settings seem adequate. An almost foolproof solution is to have your subject lean against any wall. Either seated or standing, the model will usually look and feel comfortable. Avoid being too specific about the way in which you want it done. Ideally it should be the person's body programming that determines the manner in which she leans against the wall. Since it is a body position that occurs naturally, the subject usually looks comfortable on the first try. Posture is very rarely a problem. The subject's body makes contact with the wall at several points, thereby encouraging a relaxed body stance. It is easy to animate the subject and achieve a characteristic expression under these circumstances. A single light source from a main light or a spotlight can provide all the illumination you need. Unusual prominent shadows formed by the single light source casting the subject's shadow on the wall can give a dramatic appearance to an otherwise plain background. Even unfinished walls made of cinder blocks will work very well. No matter how unsightly the wall is, this type of pose and a single light source can

turn a liability into an asset. If the wall is attractive to begin with, so much the better. A hung tapestry with a subject leaning against it and lit in the same way is a good choice (Plate 17).

Piano benches and armchairs are suitable for three-quarter length poses. Avoid sofas and chairs that sink in too much. Even if the subject feels comfortable, he or she is unlikely to look that way.

Pictures on walls can be the cause of difficulties. They almost always look crooked and the glass often shows unwanted reflections. Reflections can be minimized by tilting the pictures slightly forward. A loose ball of paper or a handkerchief can be placed behind a picture to make it lean forward. There is also the danger that the picture might compete with the subject for attention.

A business executive can be photographed seated in front of a desk. The hand treatment is similar to the one used in portraits where the arms rest on a table. (See Chapter Nine, Hands, and Figure 12.1). The background can be backlit to give good separation between the background and the subject. Another possibility is to have the subject stand behind the desk chair with arms resting on the chair back. Pay particular attention to the slope of the shoulders. (See Chapter Nine.) Seated at the edge of a desk with at least one foot planted firmly on the floor is another choice. Pictured in his or her own milieu, the subject can be encouraged to assume positions that are consistent with the body programming.

When photographing a seated woman executive, make sure that you think in terms of the female body positions and head-shoulder relationships. Your first obligation as a portraitist is to preserve this very important aspect of her likeness. Otherwise, the handling of a female executive in an office setting is similar to that of a male subject.

There are a number of precautions that should be observed in office settings:

1. Highly polished room panelling can result in hard-to-control wall reflections. Try to avoid them.
2. Unsightly desk clutter can ruin an otherwise fine portrait. Show just enough to make it look like a work area.
3. Pen sets, calenders, and other items that are in the foreground of a desk will look out of proportion and distorted because of their relative closeness to the camera. Remove them or bring them closer to the subject. Raising the camera elevation a bit will help.
4. Fluorescent lighting is frequently used for office illumination. When working with color film, consult the film manufacturer's recommendations for film type and a possible need for filters.
5. Windows in the background can cause an imbalance in the lighting if left uncovered. Either draw the drapes or increase the main light intensity.

Most location photo sessions offer a more than adequate choice of backgrounds and settings. Don't be afraid to experiment. It takes just a bit of imagination to accommodate to a change of scenery. If serious doubts arise, try several different settings. You should always be able to say, "Yes! I make house calls."

Figure 12.1
Former United Nations Secretary General Kurt Waldheim in his office. The lighting is from a main light and a reflector. The ceiling lights were left on to help give the room a natural appearance. Note the position of the hands with the emphasis on the knuckles.

Outdoors

MOST OF US ARE INTRODUCED TO PHO-TOGRAPHY by using the camera out-doors. The camera gradually becomes our third eye and we see different ways of expressing ourselves through this recording device. We find that a particular scene can be photographed from an infinite number of angles and elevations and still retain its identity. Each version, though different, will be another point of view of a scene that we felt was worthy of being recorded.

The problems begin when a model is added to the scene. The scene, when used as the background for a portrait, assumes a secondary role. The model now becomes the center of interest. If the subtleties of the model's likeness are to be preserved, you must concentrate on the subject's uniqueness, rather than on the surroundings.

Outdoor portraiture requires that the photographer use the existing illumination and adhere to the lighting principles of

portrait photography. Daylight takes the place of the main light. Unlike artificial light, this main light is stationary. If a change in the basic lighting is required, we must move the model. Although it is somewhat less manageable than artificial light, you will find many similarities. Ideal lighting conditions are more the exception than the rule.

Shaded areas or open spaces with a light overcast are usually quite comfortable for the model's eyes. The first and most important requirement is the subject's ability to tolerate the light intensity without squinting. Some people can tolerate full sunlight without noticeable discomfort. Every outdoor lighting condition has something positive to offer.

As with artificial light, outdoor main light will usually require some fill-in illumination to properly light the subject's face. Reflectors and strobe lights are the best choices. In settings with highly reflective surfaces, such as a beach or water,

you might be able to do without the additional fill-in illumination. The best indicators are the subject's eyes and neck. If they are cast in excessively deep shadow, some fill-in is needed.

Eye highlights have to be treated differently in outdoor settings. Often there will be a complete absence of eye highlights. At other times they will appear in positions that are normally not acceptable when working with artificial light. (See eye highlights in Chapter Three, Lighting.) Later in this chapter you will see how fill-in illumination can be used in some instances to induce eye highlights.

In this section we will study the lighting situations that the outdoor portrait photographer is likely to encounter.

SUNNY MORNINGS AND AFTERNOONS

Low-angle sunlight provides interesting lighting possibilities. We can take advantage of the backlighting by facing the subject away from the light. The sun's rays will fall on the subject's head and back instead of on the face. The brilliant fringe of hair lighting that results can be striking. Some fill-in is usually required on the subject's face. This can be done with a reflector or a strobe light. A reflector is more dependable. The result is immediately visible to the photographer, thereby eliminating the uncertainty associated with outdoor portraiture. If a strobe is used, it should be positioned above the model's eye level to avoid highlights near the center of the eyes.

Morning and afternoon low-angle sunlight can be used for effective profile portraits. Facing the subject into the light is one possibility. If the subject cannot tolerate the light without squinting, try turning the face away from the direction of the light. The profile will now have two additional lighting possibilities. One side of the face will be in shadow with a fringe of backlighting on the profile and the hair—a semisilhouette. The other side will receive the full sunlight. (These three lightings are covered in Chapter Ten.)

OVERHEAD SUNLIGHT

Working with strong overhead sunlight is more challenging. The contrast level is very high with the eyes and neck cast in deep shadow. A strobe or a reflector can be used to soften these shadows. If a strobe is used, remember that the flash is only for softening shadows, not eliminating them. Unfortunately there is no foolproof formula to determine just how much flash is required to soften these shadows. We have to rely on educated guesses. Let us look at our options.

1. If we reduce the exposure to compensate for the additional light provided by the flash, the background will turn dark, since the background will not benefit from the flash to the same degree as the face.

2. If the exposure is not changed and the strobe is added, it is almost certain that the facial shadows will be erased. This will leave an unnatural, flat lighting on the face. Unless the background is close to the subject, it is unlikely to be affected.

3. The most practical option is to vary and control the volume of light from the strobe. Since there is no scientific way to predetermine the exact amount of light that is esthetically required, we have to try several variations. It is likely that more than one variation will be acceptable. Each variation will lighten the shadows to a certain degree without eliminating them.

Sophisticated strobes are unnecessary. A handkerchief covering the flash works beautifully. The volume of light can be controlled by adding layers of the handkerchief. It takes a surprisingly small amount of light to soften facial shadows. Use the strobe fill-in sparingly. With some practice you will develop an instinctive feeling as to how much fill-in is required.

If you use a reflector instead of a flash, try placing it in different positions to see its effect on the shadows. As mentioned earlier, the result from the reflector is immediately visible and less likely to cause a problem.

A reflector can also be used as a shade. If you can get someone to hold it overhead, it can shield the subject's face from the direct sunlight. Your model will appreciate this comfort.

We have covered three ways of working with strong overhead sunlight and softening its harshness.

1. Using a strobe as a fill-in light and adjusting its output
2. Positioning a reflector from different angles
3. Holding a reflector or a shade overhead to shield the subject's face from the direct sunlight

These methods will also work in combination. For instance, a model's face shaded from direct sunlight might need the assistance of a strobe to soften eye and neck shadows.

MIXED LIGHT: SUN AND SHADE

Sunlight filtering through tree foliage can produce interesting lighting patterns on a face. This is a lighting situation of extremes: bright sunlight intruding on very deep shade. Unless we are seeking a high-contrast portrait, a strobe is needed to soften the shadows. A strobe will probably work better than a reflector. There may not be enough sunlight filtering through the trees for a reflector to be effective. You can move the model around while studying the different light patterns that fall on the face. For example, if a stream of light falls on the profile, you have the makings of an appealing portrait. Depending on the density of the foliage, you should be able to find enough variety to handle most portrait lighting needs.

SHADED AREAS AND OPEN SPACES WITH LIGHT OVERCAST

This even, soft daylight offers the fewest complications. Models tolerate the light well, making it possible to work for long periods with little discomfort. As with the outdoor lightings, some fill-in is usually necessary. A reflector is the preferred choice.

SPECIAL EFFECTS

Until now our study has been directed toward the use of existing lighting conditions. We have learned how to temper the unforgiving harshness of direct sunlight so that it can be used to advantage. A somewhat different approach can be used to produce a change of mood by the use of special effects.

The sky can be used as the background and made to photograph dark by using filters. Strobe lighting is used on the model's face without any regard for the existing daylight. The result is a

Figure 13.1
An overcast sky and a windy day. A red filter darkens the sky and
a strobe on the face gives a surrealistic appearance to the scene.

brightly lit face against a dark sky. With
black and white film and a red filter we
produce a darkened sky. If cloud forma-
tions are present, they will photograph
white against an almost black sky. (See
section on filters in Chapter Fifteen.) The
effect produced by this combination of a
strobe-lit face against a dark sky is some-
what surrealistic. The model's hair blow-
ing in the breeze would go well with this
scenario (Figure 13.1).

THE TRAVEL
PORTRAIT

The travel portrait can be called a portrait
of opportunity. Even if the main purpose
of a trip is not photographic, many of us
consciously search for suitable camera
subjects. The element of chance plays an
important part in how we fare. Unlike the
more formal portrait, the model will usu-

ally be photographed in the context of daily activity. Flattery of the subject should not be a necessary objective. Instead, we are looking for a way to esthetically tie in the subject with the locale. We seek a geographical setting with a strong human element.

Try to curb your enthusiasm. Do not charge up to the subject with your camera at the ready. It is more than likely that other tourists have expressed an interest in photographing this person. A discreet approach will be considered a form of flattery rather than an invasion of privacy.

The photographer is torn between the desire to get the subject's permission and a candid, surreptitious approach. If you secure a subject's permission to be photographed, you will usually gain his or her cooperation. Try not to appear aggressive. Eye contact can establish an unspoken rapport. If there is a language problem, use gestures. Be sure to observe the local cultural customs. Come in close so that the subject is not incidental to the scene. If the person looks toward you, so much the better. The eyes looking at the camera lens is always a good choice for strong expressions. Do not try to animate the subject beyond easy and simple expressions. Instead, concentrate on composition in the framing of the subject in the camera view finder. The traveler will rarely have enough time to properly study the subject for picture possibilities.

Your equipment should be as simple as possible. Time-consuming camera adjustments will take away from the immediacy of a scene. Telephoto and zoom lenses are good choices.

Try to imagine your travel portrait as a small section of a large detailed painting. The painting depicts a street scene. You have come in close and framed a small section of this scene in the camera. This section is your travel portrait. If skillfully executed, this close-up photograph will recreate in your mind the geographic setting from which it was taken (Plate 7).

BACKGROUNDS

You don't have to go far to find interesting outdoor settings. They exist all around us. Almost any background is a possibility. A portrait of a model leaning against an ordinary shingle wall with her body casting a sharp shadow on the shingles can be as dramatic as the background of the Grand Canyon. If you can see the sky, you have a foolproof background at your disposal. It always adds a sense of drama to a portrait.

Telephoto lenses make it possible to blur or subdue the detail of the setting while still keeping the model in sharp focus. Deemphasizing the background can keep it from competing with the model for attention, while still being recognizable. This is an ideal way to handle unwanted details in a background. (See section on lenses in Chapter Fifteen.)

ACCESSORIES

Now let us talk about some of the nuts and bolts of outdoor portraiture.

Sunshades

A sunshade over the camera lens is a must. Even with a lens shade there is some danger of light rays striking the lens when the sun is low on the horizon. Always look at the lens before taking a picture. If the direct light is visible on the

lens surface, change the camera position. You can usually find a camera angle that will eliminate the difficulty. Don't take unnecessary chances.

Electronic Flashes

When working with a strobe light, it should always be positioned above the subject's eye level. This will place the highlights in the upper part of the eyes. If you keep the strobe at eye level, it can cause undesirable color aberrations in the model's eyes.

A strobe used in sunlight presents an additional difficulty. Many cameras can be used with electronic flash only at slow shutter speeds. With some of the faster films used in strong sunlight, the slower shutter speeds might result in overexposure. The use of a neutral-density filter might be necessary. (See Chapter Fifteen.) This type of filter reduces the amount of light passing through the lens without altering its character.

Figure 13.2
A beach and a cloud-filled sky. A red filter darkens the sky and gives prominence to the clouds.

Reflectors

With just one exception, a reflector is a problem-free piece of equipment. Be careful when a reflector is positioned directly in front of the model. Make sure that the image of the reflector is not visible in the lower part of the subject's eyes. The improperly placed highlight will impart an eerie look to the portrait.

Filters and Polarizers

When working with color film, a corrective filter may be required in early morning and late afternoon sunlight. Color shifts occur when the sun is at a low angle. Always check for filter suggestions from the film manufacturer. Color aberrations can be minimized by the use of these filters.

Yellow and red filters will darken the sky when you use black and white film. Cloud formations will become more prominent (Figure 13.2) Polarizing filters will work similarly with color film by making the sky deeper and bluer on sunny days. (See Chapter Fifteen.)

A good portrait is possible in almost every outdoor setting. The subject will not necessarily benefit from a background of overpowering proportions. Awesome backgrounds can sometimes dilute the impact of a good character study. A simple setting can be a virtue. The subject is the center of interest and the preservation of his or her likeness is our objective. It is the treatment of the subject that ultimately determines the quality of the portrait.

Regardless of the setting and lighting conditions, a satisfactory treatment can usually be found. Keep in mind the principles of portrait photography. They work equally well outdoors.

Improving on mother nature

Photographically correctable problems may be classified into three main categories:

1. Physical differences from a generally accepted ideal norm. Some examples are a crooked or broken nose, eyes that squint, and baldness.
2. Body movements and relationships that do not conform to what we consider relaxed and attractive positions—for example, poor posture, rigid head and waist motions.
3. Skin problems—slight skin aberrations that go almost unnoticed show up as unsightly and exaggerated blemishes. Also, facial lines that are almost imperceptible and photograph like deep chasms.

In almost every instance it is possible to correct or at least visually minimize a defect. The corrective measures covered here in no way change or affect the person's

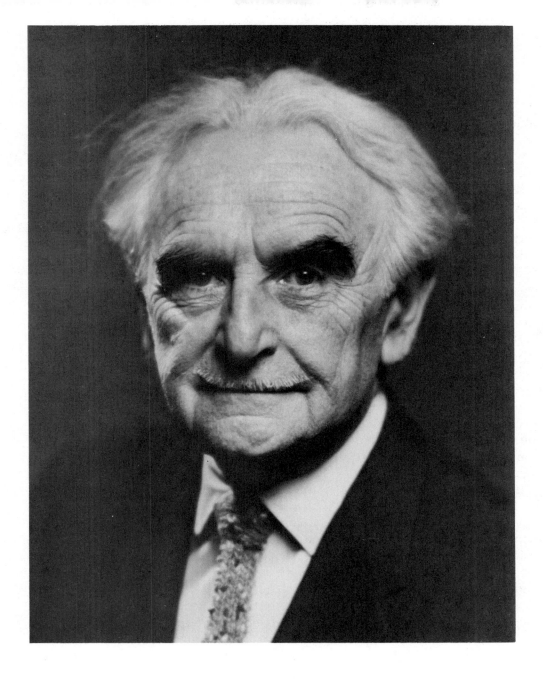

likeness. All acceptable corrections have one thing in common: You will end up with an improved version of the same person without the viewer knowing or being aware of why the subject looks so nice.

We begin our study by covering the problems that occur most frequently. The methods for correcting them are based on common sense. With some experimentation you would probably arrive at similar solutions on your own.

DOUBLE CHINS AND HEAVY FACES

"The camera makes a person look heavier." Contrary to this often stated cliché, it doesn't have to be so. The portrait photographer can actually make the person look thinner and still maintain the likeness. As with most other corrective procedures, we employ subject positioning, camera angle, and lighting to achieve the desired effect.

A table is a good prop for deemphasizing double chins and heavy faces. From a seated position have the model lean forward with arms resting on the table top. You do not have to concern yourself with the positioning of the arms and hands if they are not included in the portrait. The chair height should be slightly higher than normal. A cushion or a telephone directory can supply the added height. The camera is then positioned slightly above head level. Direct the subject to raise his or her head slightly while still continuing to lean forward. The subject should look at the camera lens. The double chin is minimized by the stretching of the skin around the neck as the subject looks up at the lens from the leaning position. The stretching of the skin also exerts a pull on the cheeks which gives the face a narrower shape. In addition the high camera angle partially obscures the neck.

We can further correct the double chin and heavy face by changing the main light elevation. Look into the model's eyes and raise the main light as high as you can without losing the eye highlights. The shadow formed around the neck by raising the main light will further conceal the double chin.

The three-quarter view of the subject is another way to make a face appear thinner. The main light should be positioned as high as possible without losing the eye highlights. Elevating the camera slightly also helps. Lighting plays an important role in making a face appear thinner. Moving the main light laterally produces varying facial shapes. When the main light is moved toward the short or narrow side of the face, the subject looks thinner. Move the main light slowly so that you can make comparisons.

These techniques, when used individually or in conjunction with one another, can produce dramatic changes in a person's appearance without changing the likeness. Prove to your subject that the camera doesn't always make a person look heavier.

NARROW FACES

Lowering the main light slightly makes a thin face appear broader. The main light should be positioned on the broad side of the face, the side with the visible ear. An increase in the fill-in illumination will also help. Smiles and laughs, which tend to spread the face, are preferable to serious expressions. Position the camera slightly below eye level.

PROMINENT EARS

When photographing women with upswept hair and men with short haircuts, keep in mind how exposed the ears can look. This is especially so when both ears are visible in the portrait. The remedy is very simple. Turn the subject to a three-quarter view position, which will in most instances completely hide one ear. A head screen (see Chapter Fifteen) is used to shade and soften the light on the other ear. Considering that ears do not contribute a great deal to our likeness, it doesn't make sense to emphasize them. If a person can be recognized by his or her ears, this is all the more reason to conceal them.

BALDNESS

How his baldness and thinning hair will photograph is a major concern to a man sitting for his portrait. Step one calls for lowering the camera slightly. From this lower position, less of the top of his head will be visible. The background light is then lowered so that the area behind the subject's head looks fairly dark. We now introduce a head screen which is positioned slightly above the man's head. A

Plate 1
Lilli Palmer as she appeared in the
television production of *The Anne Frank Story*.

Plate 2
Jose Ferrer portrayed the beggar
in the television production of *Kismet*.

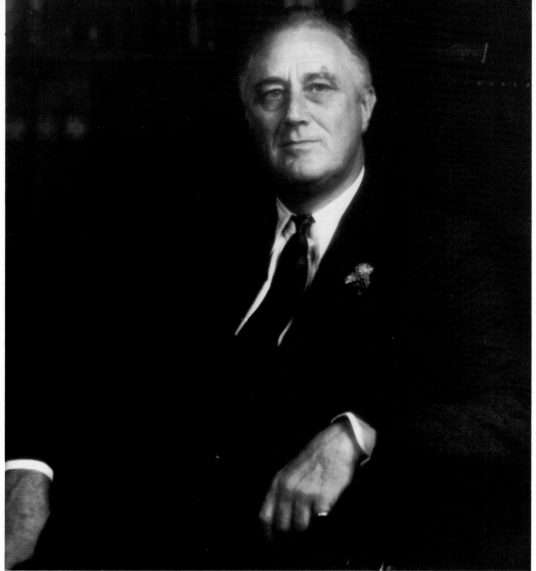

Plate 3
A rare, early color portrait of President Franklin Delano Roosevelt
from the Pach Brothers' collection of the presidents of the United States.
The somewhat subdued color is fairly typical
of color photography during that period.

Plate 4
The L.B.J. Ranch in Texas
was the setting for this portrait
of President Lyndon B. Johnson.

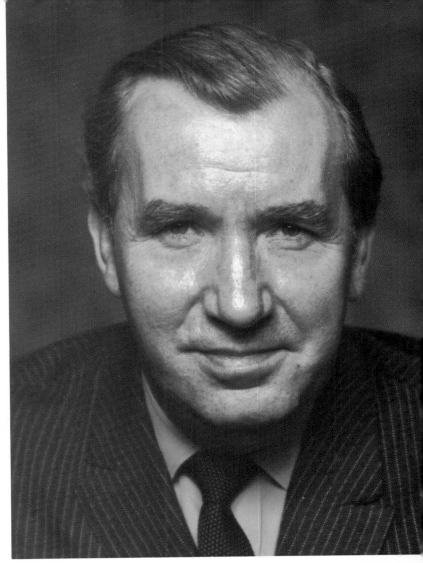

Plate 5
This portrait of Cornelius Ryan
was lit by a main light and a reflector.

Plate 6
A portrait of Dr. Lazlo Gonye.
A low camera angle makes it possible
to use the skyline as a background.
A polarizing filter deepens the blue of the sky.

Plate 7
The Gomez Family of Marbella, Spain.

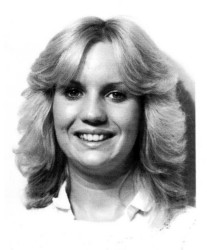

Plate 10
The subject is leaning
against a white wall. She is illuminated
by a main light and a reflector.

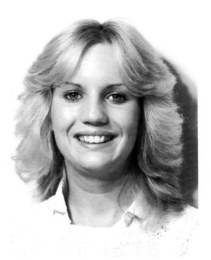

Plate 11
A floor light is added
to produce additional highlights in the
lower parts of the eyes.
Note the gleam of the teeth.

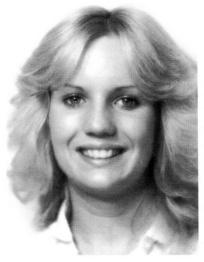

Plate 12
The camera moves in for a close-up view.
A soft-focus filter adds
a nice touch to this combination.

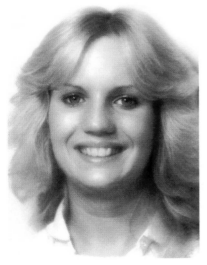

Plate 13
The soft focus is increased.
Note how the character of the portrait
can be changed by making the image size
larger and using a soft-focus filter.

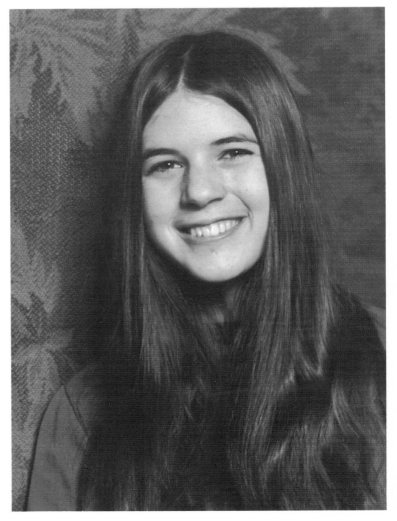

Plate 14
A single light illuminates the subject's face.
She is seated on a stool with her head resting
against a tapestry-hung wall.

Plate 15
A plant on a windowsill is the setting
for this semi-silhouette. A reflector in the foreground
provides just enough fill-in illumination
to give some detail to the face.

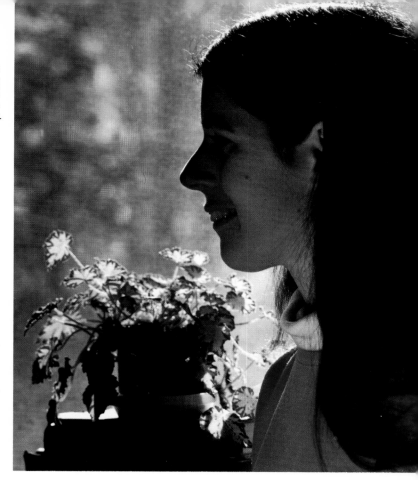

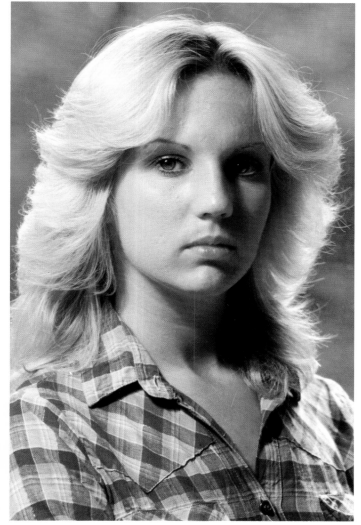

Plate 16
A window serves as the background for this portrait.
Daylight provides back lighting for the hair. Normal room light
and a reflector illuminate the face. The warmer skin tones
are the result of the tungsten light bulbs in the room lamps.

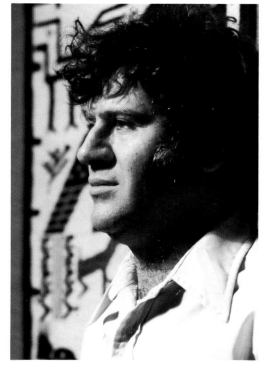

Plate 17
The subject is leaning against a wall
on which there is a primitive wall hanging.
A main light is the only source of illumination.

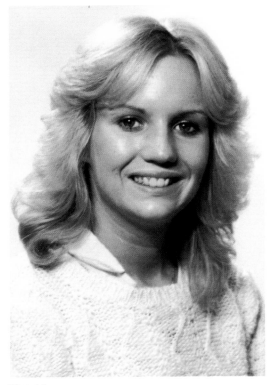

Plate 18

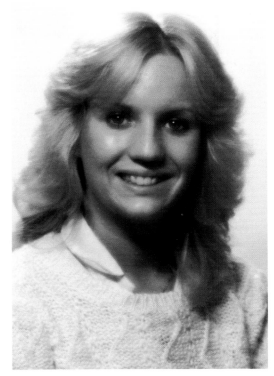

Plate 19

Plates 18, 19, and 20
Blonde hair and fair skin photograph well
against a white background. A soft-focus filter
is a helpful addition. It softens the portrait
without appearing to be out of focus. Two gradations
of soft-focus filters were used in Plates 19 and 20.
Note how they compare with the sharp
version in Plate 18.

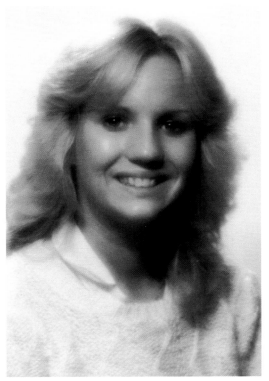

Plate 20

head screen will be used to shade the top of the head and the forehead from the main light. A shaded and darkened forehead will now blend with the darkened background. The viewer's eyes are thereby directed away from the bald head. Remember not to use a hair light (Figures 14-1 and 14-2).

Positioning a head screen is quite simple. After you have posed the subject and arranged the lighting, do the following:

1. Observe the differences in the light intensity between the forehead and the chin. The forehead will look much brighter.
2. To subdue the strong forehead lighting, position the head screen about a foot above the head and slightly in front of the subject. Make sure that the stand and head screen are not visible in the camera view finder.
3. Vary the head screen position to achieve the deisred light balance.

An ear can be shaded in a similar manner. If both the forehead and the ear require shading, the head screen can be tilted in a diagonal position to cover both areas. You can also use two head screens.

SKIN PROBLEMS

Skin problems have always been a concern to a person about to sit for a portrait. These problems usually fall into two categories:

1. Permanent conditions such as scars, skin pigmentation blotches, and unusually heavy beards
2. Temporary aberrations such as pimples, rashes, shaving cuts, and sunburn.

In the permanent category, you are dealing with a person's likeness and in a sense with the very identification of the individual. Most people are happier if we do not call attention to these disfigurements, even if they are of a minor nature.

These concerns are often out of proportion to the problems. You can be sure that the first thing the person will look for when the pictures are presented will be the defects. All the permanent aberrations have one thing in common: the aberration is a part of the individual's identification. If you completely eliminate it you effectively destroy part of that person's likeness.

The approach used in handling permanent aberrations is based on the premise that every angle or view of a person's face represents a facet of that person's likeness. For example, likeness might possibly be established on the basis of only the nose, or a combination of the nose and the eyes. The photographer places himself in the role of a graphic caricaturist who establishes likeness by drawing a few lines that represent salient features of a person's face.

Let us assume that the subject's face is severely pockmarked. You could have the person face the camera and use several head screens to shade the sides of the face and the forehead. The full intensity of the main light would then fall only on the area between the eyes and the chin. Portions of the face and the pockmarks would be subdued, but the person's likeness would remain intact. You could also use a profile view and keep everything but the outline of the profile in shadow. (Refer to Chapter Ten.) A soft focus lens and additional diffusion of the main light will further assist you in the process. The possibilities are limitless as long as you show enough of the person's face to retain the likeness.

Temporary complexion defects require a different approach. Since a change of likeness is not involved, your goal should be the complete elimination of the flaw. You can use all the methods covered in this section in addition to facial makeup. Retouching is another possibility. (See section on Retouching at the end of this chapter.)

Figure 14.1
The subject's forehead is prominent when photographed against a medium-tone background. His forehead competes with the rest of his face for the viewer's attention.

Figure 14.2
A head screen is introduced, which results in the forehead photographing darker. The background has been darkened by repositioning the background light. The forehead and the background are now similar in tone and blend into one another. The viewer is less aware of the subject's thinning hair.

THE NOSE

"I don't like the way my nose photographs!" "Don't take my profile!" "My nose always looks too large and crooked!" Portrait photographers are accustomed to hearing such declarations. These apprehensions are probably justified by the previous experiences these people have had. Unless the photographer knows how to cope with nose aberrations, even a minor irregularity can look unsightly. The portrait photographer must never accept the often-repeated statement that the camera never lies. If the nose doesn't look as good in a portrait as it does in real life, we must conclude that the camera does lie. Fortunately, this is not a final verdict.

With certain natural lightings and angles of view, people with nose irregularities look more attractive. If we learn to understand these conditions, we can simulate them and provide instant nose beauty treatments. For instance, a person whose nose curves toward one side of the face looks better if the side toward which the nose curves faces the lens. The appearance of the nose will benefit from this three-quarter view of the subject. On the other hand, a person with a long or angular nose looks more attractive from an almost full-face view. The same is true for stubby or bulbous noses.

Lighting can carry the illusion even further. As an analogy, think of a highly polished round tin can. If you illuminate the can with a single light, you will see a reflection that runs for the entire length of the can. The position of the reflections varies with the movement of the light. When you move the light slowly around the can, this reflected line of light follows along. If the surface of the can is smooth, the vertical line of light will always be reasonably straight. If you were to make a dent in the can, the line of light would look irregular and broader in the area of the dent.

Think of the nose as being this tin can. There is a natural highlight that runs for the entire length of the nose. As with the tin can, the highlight on the nose varies its position with the movement of the main light. If the surface of the nose is smooth, the line of light will be fairly straight. Any bump or irregularity will cause the line of light to waver. The shape of this line of light depends on how bumpy or irregular the nose is at a particular point. It is the shape of this line of light that determines how straight the subject's nose will look. By moving the main light and seeking out the point at which this line of light is at its straightest, we can make the subject's nose look more attractive.

Male subjects benefit more from this treatment because they usually have stronger and more visible highlights on the nose. Make-up, which partially obscures the highlights, makes the procedure less effective on some females.

Most nose aberrations can be minimized by using the techniques just outlined. In summation, they are as follows:

1. If the subject's nose curves toward one side of the face, use a three-quarter view. The side of the face toward which the nose curves should face the camera.
2. For long, angular, bulbous, or stubby noses, the best choice is a full face view.

After the subject has been positioned at the proper angle, the main light is used to complete the correction. Move the main light laterally while observing the shape of the long highlight on the nose. When the highlight is as straight as you can make it, the nose will appear at its best.

Additional minor improvements can be made on noses that fall into the second category. Elevating the head and lowering the camera slightly will deemphasize a long or angular nose. The main light should also be lowered. A stubby nose will be improved by raising the camera

and lowering the head. Raising the main light will help.

These corrective measures should be used sparingly. If the changes are excessive, other undesirable conditions occur. For example, if the camera is too low, the nostrils will be prominent. Keeping the camera too high will place the emphasis on the top of the head. As with most cures, you have to be aware of possible side effects. Make sure that the cure isn't worse than the disease!

SLANTED AND CROOKED LIP LINES

Slanted lip lines can be made to look straighter by taking advantage of a simple optical illusion. Tilt the model's head so that the lip line appears to be parallel to the shoulder line. This works well when the model faces the camera.

Another optical illusion can serve for three-quarter views of the face. Turn the model to a three-quarter view position. The side of the face in which the lip line looks higher should be toward the camera. While looking in the viewfinder, tilt the model's head so that the lips are parallel with the bottom of the viewfinder frame.

Smiling expressions tend to increase the lip slant. Explore the different expression possibilities and pick a happy medium.

Also consider a profile view, which will completely eliminate the difficulty.

LIPS AND TEETH

Some people find it difficult to get their lips to touch. Unless the lips make light contact effortlessly, avoid nonsmiling expressions. Forcing the lips to touch always looks contrived. For the subject with nice teeth, a smiling or laughing expression is a good choice. A profile pose is a way to avoid showing unsightly teeth. You can take advantage of hand poses by having the subject rest his chin in his hand. The fingers can then be used to cover the lips. These forms of natural camouflage are always good solutions.

CROSSED EYES

People with crossed eyes can be photographed with good results. The photographic correction of the eye problem must become the primary objective, with other photographic difficulties relegated to less important roles. Instead of the usual subject appraisal procedures, start with the following:

1. Stand in front of the camera with the seated subject facing you.
2. Hold your left hand up to your face and, keeping it at the same level, slowly move it to your left. Direct the subject to follow your hand by turning the head and eyes as a unit. Make sure that the eyes and head move together. Study the subject's eyes. The degree of eye misalignment will appear to vary as the subject moves. You will usually find a position from which the aberration is least obvious.
3. When you have found this point you are ready for the final adjustments. From this new position, keep the subject's head stationary and have him or her follow your moving hand, using only the eyes. This enables you to fine tune the eye alignment.
4. Repeat the entire procedure using the right hand and moving in the opposite direction.

Be systematic so that you can make comparisons during the procedure. The

subject will appreciate your efforts and his or her improved appearance.

You should also consider a profile as a last resort. For artificial eyes follow the same procedure.

NARROW EYE OPENINGS

Careful subject positioning and camera elevation can make the eye openings look wider. Ask the seated model to lean forward from the waist with the arms resting on a table. This is the same position that is used to correct a double chin. The camera is placed at a level slightly above the head, and the model's eyes are directed at the camera lens. You will see an immediate change in the size of the eye openings. The next step is to vary the camera elevation while the model continues to follow the camera lens. Watch for the changes that occur in the eyes. There will usually be a point when the eyes are at their widest.

Blinking the eyes on command is the next step. The eyes are at their widest immediately following a sharp blink. The type of blink is very important. If the blink is too quick it will not be effective, nor will a quick fluttering of the eyelids. It must be a deliberate blink in which the lids meet firmly but do not continue to press down on one another. Explain the procedure to the subject and try some variations before the actual picture taking. The subject's cooperation is essential. In extreme situations, when the eye openings are just narrow slits, ask the model to look slightly above the camera rather than directly into the lens.

Some people are so sensitive to light that they are unable to tolerate even low levels of illumination without squinting. A good way to deal with this difficulty is to make all the lighting and body positioning preparations while the subject's eyes re-

main closed. The next step is to select the point at which the subject will look when the eyes are opened just prior to the exposure. Try a few dry runs. Ask your subject to open his or her eyes so that you can study the action of the eyelids. Most likely there will be a short interval during which the eyelids remain more open than in their usual squinting state.

Once you have seen the predictable pattern of the eyelid behavior, you can proceed to make the exposures. Strobe lights are a great help in dealing with this problem.

ABSENCE OF EYE HIGHLIGHTS

Drooping eyelids often make it difficult to place highlights in the subject's eyes. This is especially so with elderly people. The upper lids cover the portion of the eyes on which the highlights would usually be located. Considering the importance of these highlights, every effort should be made to overcome this difficulty. Lowering the main light too much is not an acceptable solution since it will place the highlights on or near the pupils.

A technique that will often solve the problem is based on the fact that the eyes and the eyelids do not move as a unit. For example, if you try to look up toward the ceiling without raising your head, your upper eyelids will be raised to compensate for the fixed position of your head. When you lower your eyes the lids will follow, but they will lag slightly behind the eyes as the eyes return to their original position. It is during the interval that it takes for the lids to catch up with the eyes that the eye highlights become visible. The upper parts of the eyes, which were covered by the drooping lids, remain exposed during this period.

To implement this technique, use the following procedure:

1. Place the main light low enough to get highlights in the eyes, even if they fall in the vicinity of the pupils.

2. Raise the main light slowly until the highlights barely disappear from view.

3. Set the camera height to slightly above the subject's eye level and ask him or her to look at the camera lens.

4. While looking at the subject's eyes through the camera view finder, raise one of your hands as high as you can.

5. Ask the subject to look at your raised hand, but to do so without raising his head. Continue looking at the subject's eyes.

6. Direct the subject to look at the camera lens again. As the eyes resume their original position, watch for the highlights to appear in the areas that were covered by the drooping lids. See how long it takes for the lids to once again cover the highlights.

By repeating the procedure several times, you will arrive at a predictable pattern. You will be able to make the exposures while the highlights are visible.

Although this technique works best with mature people, it is worth trying whenever you encounter an eye highlight problem. The nice thing about this system is that the results never look artificial (Figures 14.3 and 14.4).

Figure 14.3
The subject's upper eyelids cover the sections of the eyes that usually contain the eye highlights. The absence of eye highlights results in a loss of animation. There is a vagueness of direction in the eyes. It is difficult to tell where he is looking.

Figure 14.4
The eye highlights are now visible. We took advantage of the eyes
and the upper eyelids moving independently of one another. The
subject was asked to look up without raising his head. He was
asked to look at the camera lens. There was a short interval of time
in which the eyelids lagged behind the eyes as they returned to
camera level. It was during this interval that the exposure was
made. The presence of eye highlights gives additional strength to the
portrait.

INVOLUNTARY EYE MOVEMENT

This condition is characterized by the involuntary drift of one eye while the other eye remains in a fixed position. The model is usually aware of the uncontrolled, free-moving eye and can be of assistance in handling the condition. Even if the subject fails to mention the eye difficulty, don't pretend that it doesn't exist. To get a good result you will need complete cooperation.

The drift of the eye probably follows a predictable pattern. Once you learn this pattern, you will be prepared to make the exposures when the conditions are at their best.

Before you tackle the eye problem, go through the regular routine of subject positioning and lighting. This eye condition itself usually does not limit the subject's good picture possibilities. Suppose you have selected a three-quarter face pose with the subject looking at the camera lens. As the subject continues to look at the lens, one eye will begin to drift horizontally either toward the nose or the ear. In order to observe the eye drift several times so that you can learn its predictable course, you must start the sequence from the beginning each time. Ask the subject to look in the direction opposite to where the eye has drifted. When the eyes appear to be aligned, direct the subject to look at the camera lens again. Repeat the procedure as often as necessary. Each start of the cycle should give you enough time to make a single exposure with the eyes properly aligned.

It can be a time-consuming and exasperating experience. Take your time and don't panic. The subject will sense your discomfort.

Eye drifting also occurs vertically. It often goes unnoticed because the lids help conceal the condition. If it presents a problem, the same procedure using vertical movements will do the trick.

Another form of involuntary eye movement is the rapid oscillation of the eyes. Although there is usually a position of least or no oscillation, the point at which it occurs may not be suitable for a portrait. You can explore this possibility by having the subject look in different directions while keeping the head in a fixed position. Look for the point at which the eye motion is reduced. If you find such a position and it conforms to one of the usual head-eye relationships, you should be able to photograph a good likeness. If you cannot find such a position it is best to rely on high-speed photography. This condition is best handled by a quantity of exposures and the law of averages. Strobe lights will freeze the motion. If you take enough exposures you will end up with satisfactory results. This is one of the few situations where a large quantity of exposures is desirable.

CONSTANT BLINKING

Trying to make the exposures between uncontrolled blinks of the eyes can be like a game of tag. The photographer can become so absorbed with the blinking that he or she is forced to ignore other pressing needs. Some blinks are a form of compulsive habit. Most of the blinks, however, are due to the person anticipating the instant of the shutter action or flash. This type of subject usually blinks at the slightest sound or movement of the photographer.

Cooperation between the subject and the photographer is essential. A remedy that often works is to have the subject blink on command just before the expo-

sure is made. Explain the situation to the subject and then try several dry runs. A predictable sequence of blinks will usually emerge. Another approach is to mask the noise of the shutter by talking to the subject during the time of the exposure.

DEEP-SET EYES

The easiest way to handle deep-set eyes is to lower the main light. Try to avoid getting the highlights on the pupils. Additional fill-in illumination from a reflector or fill-in light also helps.

GLASSES

Reflections on eye glasses are always a problem. They are usually caused by the glasses reflecting a mirror image of the main light which shows up as a glare on the lenses. They most often occur on the upper part of the glasses, either covering part of the eyebrow or between the upper eyelid and the brow. In extreme situations they will cover part of the eye. Many of these reflections can be eliminated by changing the main light position or by tilting the subject's head. Usually a combination of the two is required. Since major changes in lighting and subject position are rarely needed, go about the business of arranging the subject before you tackle the reflections.

With this accomplished, direct the subject to look at the camera lens while you observe him or her through the viewfinder. Raising the main light or lowering the subject's head brings the reflections higher up on the glasses. If you raise the main light high enough or lower the subject's chin sufficiently, you will eliminate

the reflections. There are, however, limits as to how much of a change you can make in the main light and chin elevations. The eye highlights are your guide, and they are affected by these changes. These changes must not result in the loss of eye highlights, which ideally should appear just below the upper lids. With this in mind, adjust the main light and chin positions until you minimize or eliminate the reflections. If some reflection remains, move the main light laterally in both directions. Tilting the glasses slightly forward will also help. With most glasses these procedures will take care of the difficulty.

On occasion you will come across glasses from which you cannot completely eliminate the reflections. Even in the these extreme situations you can usually manipulate the main light so that the reflections fall on the edges of the lenses rather than over the eyes. Retouching these reflections is another possibility, and it is covered later in this chapter.

Reflections on glasses can also be caused by fill-in lights and reflectors. These are easily eliminated. Fill-in lights should be elevated and moved laterally until the reflections are no longer visible. Glare caused by fill-in reflectors is the result of the reflector being too near the camera position. Moving the reflector to the side solves the problem.

People with wide glasses usually photograph best in full face poses. Three-quarter views tend to look distorted because part of the cheek is viewed through the eye glass lens, which makes the cheek line appear irregular.

Although they can be effective when worn for cosmetic reasons, tinted glasses often look different in photographs. The eyes usually lose their brilliance, and the area around the eyes looks too dark. Sometimes there is a loss of separation

between the eyebrows and the area surrounding the eyes. When possible, also shoot a few negatives with clear lenses.

When glasses are worn only part of the time, it is a good idea to try some exposures with and some without the glasses. Glasses can often improve a person's appearance. If the subject has small eyes, and the glasses make them look larger, the glasses will enhance the appearance.

Lensless frames would appear to be an ideal solution for all photographic problems caused by glasses. However, this is not the case. Although some photographers use them, they always look artificial. When glasses are worn, some form of reflection is usually present on the skin in the area of the cheeks and eyes. We have been conditioned to accept these catch lights on the skin as a part of wearing glasses. Their absence creates a disturbing inconsistency. With likeness being as fragile as it is, don't do anything that will obviously look unnatural.

POOR POSTURE

A person with poor posture sometimes looks uncomfortable when trying to sit erect. Because he or she is so accustomed to slumping, any attempt to straighten the back makes the subject look awkward. The neck will often develop bulges that are not visible from the usual slumped position. A good alternative is to have the subject lean his or her arms on a table. With the weight of the torso supported by the arms, we end up with better posture, a relaxed neck, and a more comfortable subject. Ask the subject to raise his head from this leaning position and look at the camera lens. The camera should be placed slightly above eye level.

THE NERVOUS SUBJECT

Even the most relaxed subject is affected by the presence of the camera. It exerts a slightly inhibiting influence on most people, and causes sheer terror in others. Our concern is with the latter.

For some people, a photograph assumes an inordinate role of importance. These people respond to the photographer's directions with stiff, robot-like motions and generally look very uncomfortable. You sometimes get the feeling that you are a physician dealing with a patient who is concealing symptoms. These subjects usually expect the worst and are often surprised at how nice they look. At times they will voice their concerns, which, for the most part, are not too difficult for the portrait photographer to handle. These subjects need sympathetic reassurance.

If you see an obvious concern such as baldness, don't wait for the subject to mention it first. In a matter-of-fact way tell him how you plan to deal with the problem. You will in a sense disarm him, because he probably keeps his chin up too high hoping to make his bald head less visible. Regardless of what the difficulty is, if you see anything that might bother the subject, talk about it.

Most people, when directed to keep their eyes at a particular point, will move the eyes and head as a unit. The head and the eyes will accommodate to each other's positions. Because of this, the change in eye direction looks completely natural. The nervous subject, on the other hand, is likely to respond with a robot-like movement of only the eyes. (See head-eye relationship in Chapter Two, Subject Appraisal.) If you use less specific terms such as "Direct your *attention* to this point," the model is more likely to move the way he or she would off camera. You

can fine tune the changes afterward with more specific directions.

This type of subject sits much too erectly. Ask him to slump slightly, thereby achieving a natural head-torso relationship. Explain the reason for leaning forward and assure him that he will not have poor posture in the portrait.

Keep in constant touch with the person by avoiding long periods of silence. Don't resort to irrelevant conversations. Subjects are too concerned with their own problems and do not want to be distracted. They might also feel that you are not paying sufficient attention to the job at hand.

Develop a rapport with the person. His or her confidence in you will increase as the sitting progresses. Avoid erratic movements, and, even if you are puzzled about a particular problem, try not to show it. You have succeeded in casting a spell on the subject. Don't break it until you have completed your task.

WRINKLES

A more diffused main light helps soften wrinkles. Position the main light slightly further away from the subject than usual. The increase in distance between the subject and the main light will diffuse and soften the light falling on the face. Lowering the main light a bit can also help. Avoid broad smiles, since they tend to increase the depth of the wrinkles. Placing the camera further back makes the image smaller and further reduces the emphasis on facial lines.

You should also consider the use of a soft focus lens. (See Chapter Fifteen, Equipment.) It takes some of the harshness out of reality.

RETOUCHING

Although retouching doesn't fall into the scope of this book, a knowledge of its function is important. Retouching is one of the least understood techniques used by the portrait photographer. During the evolution of portrait photography, the use of retouching was often abused. It was the accepted practice to retouch in order to make a person look better, even if it destroyed the likeness.

Many people are still influenced by the excesses that were used in the past. In practice, the judicious use of retouching can be a means of preserving likeness. The portrait photographer's objective is to record a reasonable facsimile of what is seen through the camera viewfinder. Unfortunately, photographic film doesn't see the subject in quite the same way. It sees lines and wrinkles that are almost invisible to the naked eye. Slight variations in skin pigmentation can look like unsightly blotches. Does the camera ever lie? Yes, it does. Photographic film can make mountains out of mole hills and in every sense exaggerate the truth.

Pencils and dyes are the materials used in negative retouching. The negative is placed on a light box similar to the type used to view slides or x-rays. The pencil lead or dye is applied to the area in need of retouching. For example, a wrinkle as it appears on a negative would be more transparent than its adjacent areas. By using pencils or dyes to add density to the wrinkle, we reduce its transparency. The more pencil lead or dye applied, the less apparent the wrinkle becomes. Rings under the eyes, skin blemishes, and other aberrations can be treated similarly.

In a clinical sense, you could say that the camera can predict the future. A close-up photograph can reveal details that are not apparent to the naked eye. It

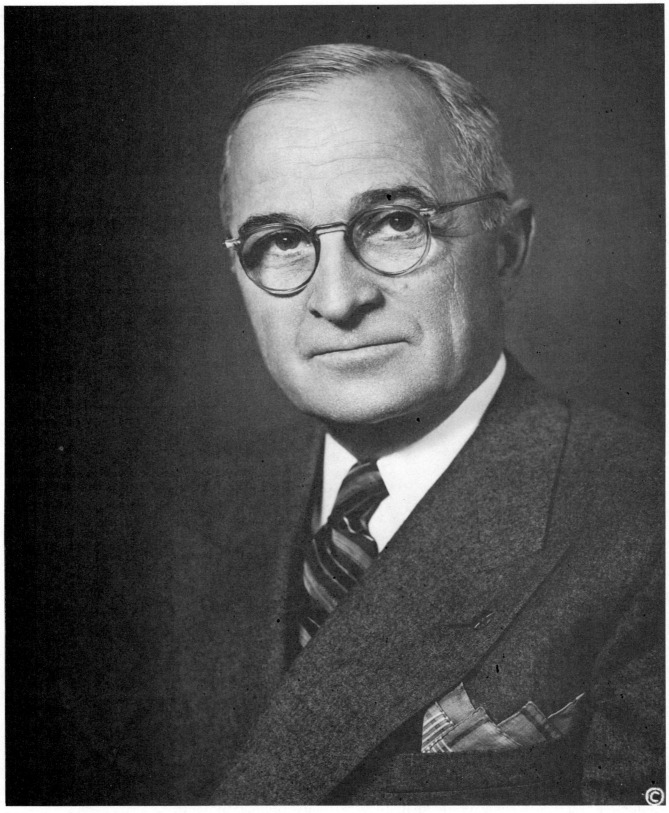

Figure 14.5
President Harry S Truman's portrait was taken in the Oval Office
of the White House.

makes us look older than we are. The portrait photographer can keep the photograph in its proper time frame through the use of diffused lighting and soft-focus lenses. Retouching is another means of staying in the present. It must be used in moderation. Excessive retouching will make us too youthful, and thus return us to the past.

In practice you could do a moderate amount of retouching on a photograph and each succeeding year remove some of the retouching. If retouching were removed gradually, you could keep pace with the subject's normal aging. This example is more than just hypothetical. It has been used as a means of giving a current look to a portrait done in the past.

Retouching can also be done on a print. Lines and blemishes can be softened by the use of dyes and pencils.

Highlights on glasses that cannot be eliminated during the sitting can be removed or softened.

CONCLUSION

Reality in a portrait can have many meanings. There is the reality of a squinting naked face in harsh sunlight and that same face under soft gentle living room illumination. Each constitutes a form of likeness. Given a choice, most people prefer the latter. The material covered in this chapter will assist you in presenting the subjects at their best.

There is no harm in idealizing a person. People rarely resent being given a compliment.

CHAPTER FIFTEEN

Equipment

Photographic equipment is rarely designed specifically for the portrait photographer. Most of what is available is multipurpose in nature. This seeming oversight should encourage us to fully understand portrait concepts so that we may utilize comfortably whatever is available. We can improvise and often add a personal touch to the way a piece of equipment is used. Some of the accessories can be simply constructed at modest cost. In this chapter we discuss the choices that are available to the portrait photographer.

CAMERAS

There is no ideal camera or film size for portraiture. Almost any camera with controllable exposure settings will do. Each type has advantages.

Traditionally, the large-format view camera was the portrait photographer's workhorse. This has largely changed. The convenience of roll film cameras has made their increased use inevitable. Although there is a direct relationship between film size and picture quality, current camera and film technology has reduced these differences.

View cameras have the advantage of a large format such as $4_3 \times 5_3$ or $5_3 \times 7_3$. You can also make focusing and perspective adjustments by changing the angle between the lens and the film plane. For example, a subject seated with folded arms resting on a table top can have both the arms and face in focus even though they are on widely different planes. With other types of cameras a small lens aperture and a dependence on the resulting depth of field is required to produce a similar effect.

Although roll film adapters are available for view camera use, most photographers use sheet film. Sheet film must be loaded into film holders in a darkroom. Each film holder contains two sheets of film. It is somewhat cumbersome when compared to the ease of using a 35 mm. camera. Focusing is accomplished by looking at an inverted image of the subject on a ground glass while making bellow length adjustments for sharpness. Since the inverted image on the ground glass is very dim, a focusing cloth is placed over the photographer's head and camera back for easier viewing.

A view camera is a very simple device—somewhat primitive in terms of current technology. This can be an advantage. There is no reliance on automation. The photographer can maintain intimate control over the equipment without fear of mechanical failure.

There are some minor occupational hazards connected with the use of a view camera. Viewing the inverted image will cause you to twist your neck while the focusing cloth musses your hair. On the positive side, it impresses the subject and makes you, the photographer, look more professional.

Roll film cameras have many advantages in portrait photography. The photographer can record subtle nuances of expression with a minimum of fuss. Speed and maneuverability eliminate the restraints of more cumbersome equipment. Contemporary children's portraiture is largely dependent on the flexibility and speed of roll film cameras.

Ideally the camera should be the reflex type so that the image size and composition are easy to see and adjust. For the best results it is important to take full advantage of the available film area. Image size is directly related to the quality of the enlarged final print. The small format size of roll film cameras makes it essential that the image fills most of the film working area.

The following list gives the operating steps and characteristics of view and roll film cameras as they apply to portraiture:

VIEW CAMERA
1. Open shutter to permit focusing and composing.
2. Close shutter.
3. Insert film holder and remove safety slide.
4. Make exposure.
5. Return safety slide and remove holder.

Repeat this sequence for each exposure.

ROLL FILM CAMERA
1. Focus and compose.
2. Make exposure.
3. Wind film.

VIEW CAMERA ADVANTAGES
1. Large film size produces very good quality.
2. There is little chance of mechanical failure.
3. Perspective distortion can be minimized.
4. Extremely fine adjustments can be made in focusing.

ROLL FILM CAMERA ADVANTAGES
1. Manueverability and speed are possible.
2. Film is relatively inexpensive.
3. Image can be viewed right side up.
4. A darkroom is not required for film loading.
5. Color slides are easily made.

Regardless of which type of camera you elect to use, remember that the camera is only a recording device. By itself it is incapable of creativity. At best it can only give permanence to the impressions you place before its lens.

LENSES

The lens you select for portraiture will function as your third eye. From a particular position of view the lens should be able to see what you see. A suitable lens allows you to position the camera far enough away from the subject to keep the portrait free of perspective distortion. The camera should also be close enough for you to maintain eye contact with the subject. Unlike other types of photographs, such as landscapes, even a slight amount of distortion can have an adverse affect on a portrait. The same landscape can be photographed with an infinite variety of lenses and still be identifiable and pleasing. Likeness in a face is too fragile to tolerate these liberties.

Personal preference plays an important role in lens selection. For example, with a 35 mm. camera a range of focal lengths between 100 mm. and 135 mm. is suitable for portraiture. A near-sighted photographer would be more comfortable viewing the subject from a distance closer than usual. Since the 100 mm. lens makes it possible to keep the camera closer to the subject than the 135 mm. lens, the near-sighted photographer would select the 100 mm. lens. With either lens the portrait would be reasonably free of perspective distortion.

Another factor that must be considered in lens selection is the size of the working area. Make sure that the room is long enough to use the lens you select. The wrong lens can restrict the picture possibilities.

Zoom Lenses

A zoom lens has a variable focal length. This feature makes it possible to change the image size without changing the camera position. When set at an appropriate focal length it can be used for portraiture. Although it is a bit unwieldly, many photographers feel that the advantages outweigh the disadvantages.

The following list gives the lenses that are suitable for portrait photography:

FILM SIZE	APPROXIMATE FOCAL LENGTHS OF LENSES IN MILLIMETERS
• 35 mm.	• 100 to 135
• 2¼″ × 2¼″ to 2¼″ × 2¾″	• 135 to 180
• 4″ × 5″	• 180 to 225
• 5″ × 7″	• 225 to 350

Within the ranges of lenses suggested for a particular film size, the differences in the resulting pictures will not be startling. A good rule of thumb is to use the longer focal length lenses for close-ups.

EXTENDERS

You might consider using a 2X extender (also known as a teleconverter) to adapt your present standard lens for use in portrait photography. An extender is a relatively inexpensive accessory that increases the focal length of a lens, making it suitable for portraiture.

SOFT FOCUS DEVICES

Soft focus lenses and filters have a definite place in portraiture. They give rise to

a reality of their own. It is a reality that we see when we half close our eyes and look at someone's face in a dimly lit room. When properly used they can create a mood.

A slightly diffused portrait, especially if the head size is large, looks more natural than a razor sharp image. Soft focus devices are excellent when used on elderly people. Regardless of a subject's age, all sorts of skin aberrations and lines can be effectively softened without changing a person's likeness.

Soft focus equipment comes in several forms. A lens specifically designed for this purpose is the best choice. A diffusion filter that converts your existing lens for soft focus use is a less expensive but adequate substitute. Although the results are not quite the same, they both offer a satisfactory way to soften harshness in a portrait.

Soft Focus Lens

A soft focus lens varies in sharpness in relation to the lens aperture. The image is at its softest when the lens aperture is wide open. It gets increasingly sharper as the lens opening is reduced.

A soft focus lens is sharpest at the actual point of focus. For example, if the focus is on the subject's eyes, the eyes will be relatively sharp. Adjacent areas of the face will fall off in sharpness gradually in an unobtrusive way. The result is quite similar to the way our eyes see a face from close up.

A soft focus lens can be difficult to focus when the aperture is wide open. If your camera makes it possible for the photographer to see the effect of different lens apertures on the image, it is best to focus the camera with a small aperture. You can reset the lens to the required opening before making the exposure.

Because the degree of sharpness is dependent on the lens aperture, a broad range of soft focus effects are possible from a single lens. With some practice you will be able to judge the extent of soft focus that is needed to benefit a particular subject. Although there are no absolute rules, close-ups generally look more flattering when they are on the softer side.

Soft Focus Filter

The filter is an inexpensive accessory that fits over the lens and gives an overall diffused appearance to a portrait. The degree of softness is constant for a particular filter. Filters are available in various gradations of diffusion. A soft focus filter can be improvised quite easily. A piece of nylon hosiery stretched over the lens can serve as a diffuser.

THE MAIN LIGHT

Whether working with strobe or incandescent light, the key to lighting the subject's face is the main light. Good portraiture is possible with either type of lighting. Each has its positive features and disadvantages. Ideally you should be comfortable with both strobes and incandescents. For the purposes of studying portraiture, the incandescent light is a better teaching device.

Some improvisation is required to produce a suitable incandescent main light. A simple unit that I designed works extremely well. It consists of two clamp-on reflectors fitted to a single light stand. The two adjacent reflectors are covered with a diffuser to form a single broad light source (Figures 15.1a, b, and c). Suitable diffusers can be made from waxed paper

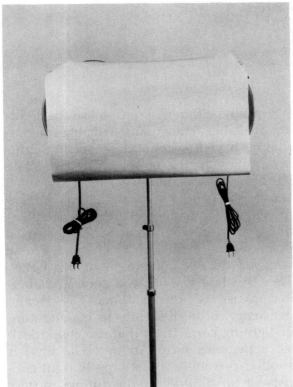

Figures 15.1a, b, and c
An excellent and easy-to-construct main light.
Two clamp-on reflectors are attached to a stand.
When a diffuser is placed over the reflectors we
end up with a single light unit. Four clips are
clamped to the edges of the reflectors. The clips
support the diffuser and keep the material from
making contact with the hot reflectors. Paper clips
are used to fasten the diffuser to the clamp clips.
Spun glass, Mylar, wax paper, and tissue paper
make good diffusion materials.

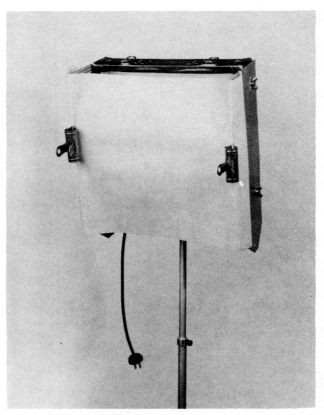 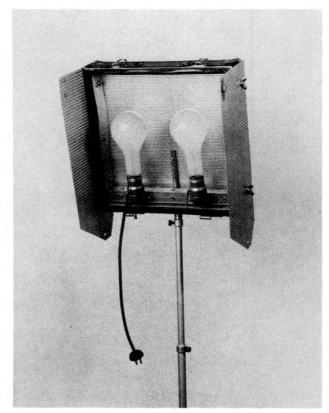

Figures 15.2a and b
Another version of a main light is a wooden box about 15″ × 15″ (the size is not critical), lined with a reflective material such as aluminum foil. A coat of white paint on the inside of the box can also serve as a reflector. Two light bulb sockets are mounted on the bottom. A diffuser is supported by two pieces of wood, masonite, or aluminum, which is then fastened to the sides of the box. The supports for the diffuser should be wide enough to keep the diffuser from making contact with the light bulbs. You should allow at least 6″ of space between the light bulbs and the diffuser.

(the type used as sandwich wrapping) or ordinary white tissue paper. A sheet of Mylar makes an excellent diffuser. Even a couple of white handkerchiefs or a piece of white bedsheet will do. Use your imagination. The light bulbs can be ordinary 500-watt photo lamps. Several different types are available to accommodate to the various film emulsions. (When using color film, check for the manufacturer's suggested bulb type.)

Another type of main light construction consists of a simple wooden box with two light bulb sockets mounted on the inside. The diffusers and light bulbs are the same for either version (Figure 15.2a and b).

Many different kinds of strobe lights are available. Those most suitable for portraiture have low-intensity modeling lights in addition to the strobes. The modeling light provides a continuous light source. It serves as a guide so that lighting adjustments can be made visually. The illumination provided by the strobe flash is used in the actual exposure. Less sophisticated versions do not contain modeling lights. They are less flexible and somewhat limited in use as portrait lights. Their major deficiency is the difficulty in making subtle lighting corrections that can help idealize a person's face. An umbrella light is another possibility. This type of light consists of an umbrella whose inner surface

has been coated with a reflective material. A light bulb is directed toward the reflective surface, which in turn emits a soft, fairly even illumination. Although easy to use, the illumination is a bit too general for head and shoulder adult portraits. It results in a blandness of light that is better suited to full length subjects. Difficult-to-control young children can benefit from the general illumination of umbrella lighting. The umbrella concept can be used with both strobes and incandescent lights.

Lighting equipment selection can be bewildering to the novice portraitist. A great deal of improvization is possible on a very personal level. You can equate it with the portrait painter who might shave a few hairs from a brush to achieve a certain effect. Some items can easily be built. A certain amount of flexibility is surrendered by just using what the manufacturer says is right for you. After you have become comfortable with portrait lighting concepts, you will be able to adjust to almost any type of equipment.

Before we discuss the additional lighting needs of the portrait photographer, we should be aware of the advantages and disadvantages of strobe light and continuous incandescent light.

The following list compares the two types of light sources:

STROBES

1. High speed virtually eliminates moves and reduces the possibility of blinked eyes.
2. Strobe light mixes well with daylight.
3. Room temperature is not raised appreciably; subject is comfortable.
4. A high degree of consistency of exposure can be maintained.
5. Smaller lens apertures can be used when needed.

INCANDESCENTS

1. More intimate control over lighting is possible.

2. Corrective measures on facial aberrations are more easily accomplished.
3. Subject's pupil size is close to the way it would appear in normal room light.
4. Subject does not wince when flash is not anticipated.
5. There is less reliance on mechanical devices.

FILL-IN LIGHT

The size of a fill-in light is not critical. With incandescent lighting, use a reflector with a single 100- to 200-watt light bulb. It is better to use low light intensity and come closer to the subjects than to employ a brighter fill-in light. Too strong a fill-in light can result in a blandness of tone and add fullness to the subject's face (Figure 15.3a, b, and c).

BACKGROUND LIGHT

Any small reflector mounted on a stand can serve as a background light. If an incandescent bulb is used, it should be between 60 and 100 watts. With strobe lights, a number of small flash units are available Since it is positioned between the subject and the background, a background light must be small enough to be concealed by the subject's body (Figure 15.4).

A larger light bulb may be needed when working with color film (see Chapter Eleven). This is essential if the accuracy of the background color is important. The light intensity should be similar to that which illuminates the face. Some experimentation is usually required to arrive at a proper lighting balance.

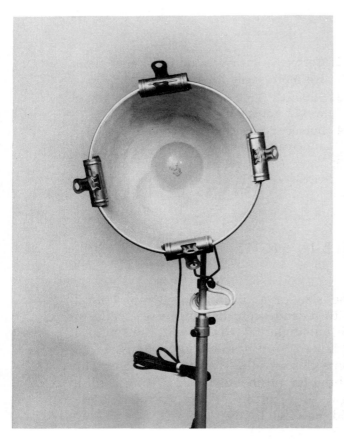

Figures 15.3a, b and c
Fill-in light. A single reflector similar to the one used on the main light makes a good fill-in light. The light should be diffused in the same manner as the main light.

Figure 15.4 (left)
Background light. Either of these devices will serve as excellent background lights when mounted on a stand.

Figure 15.5 (below)
Spotlight. Hair illumination and spotlighting with adequate control can be obtained from either of these lights.

SPOTLIGHTS AND HAIRLIGHTS

Lights suitable for accent and hair illumination are readily available both in strobes and in incandescents. When working with incandescents, you can improvise a spotlight by using either a small reflector flood or a reflector spotlight bulb. These are standard light bulbs that are used primarily for nonphotographic purposes. They come in 75- and 100-watt sizes and are only a small fraction of the cost of a spotlight (Figure 15.5).

Barndoors (shades that fit on either side of a light to control light direction) that fit over these bulbs can be used to adjust the intensity and direction of the light. Spotlights can be mounted on photographic light stands. In permanent installations they are usually suspended from the ceiling, hanging low enough for easy control.

Figure 15.6
Reflector. A white sheet of mat board clipped to a stand makes an excellent reflector.

REFLECTORS

Almost any light-reflective material can serve as a reflector. It can be a piece of white mat board or a white cloth mounted on a stretcher (Figure 15.6). Aluminum foil pasted to a stiff cardboard works well. The size is not critical, but it should be at least 24″ × 30″ to be effective. A large mirror set on casters makes an excellent reflector when portability is not important. Unlike other reflective materials, from certain angles a mirror will introduce an additional highlight in the subject's eyes. It can easily be avoided by slightly shifting the angle of the mirror.

If you do not want to improvise, many different types of reflectors are sold commercially. Any of them will work well in their function of softening shadow areas.

HEAD SCREENS

A head screen is an often neglected but very useful accessory. The function of a head screen is to selectively shade parts of the subject's face from the main light. It is particularly effective for reducing the light intensity on the forehead of a male with thinning hair. Even with a full head of hair, a mature male often requires some forehead shading. Ruddy complexion tones, sunburn, and oily skin create unflattering clusters of strong highlights on the forehead. This can be effectively deemphasized by the use of a head screen.

Ears frequently require shading. In three-quarter views of the face, the ear nearest the camera is often too conspicuous. Shading the ear with a head screen shifts the viewer's attention away from the ear and directs it toward the rest of the face.

The logic governing the use of a head screen is sound. It is a way to deemphasize areas of the face that are unflattering to the subject, without changing likeness.

A head screen is a small black shade about 9″ × 12″ (the size is not critical) set on an easy-to-move lightstand. The shade can be connected to the stand with a large clipboard-type clip. A piece of black mat board makes an ideal head screen, but any stiff, black material will do. You can improvise any number of different versions. They are so easy to make that they are not worth buying (Figure 15.7).

Figure 15.7
Head screen. A piece of black mat board approximately 9″ × 12″ can serve as a head screen. An ordinary clip is used to fasten the mat board to a stand. The angle and elevation of the head screen are easy to adjust.

BACKGROUNDS

The background should not compete with the subject for attention. In studio settings it is usually placed far behind the subject so that it is not in clear focus. The viewer sees only the tone of the background and has no conception of its composition beyond the shades of light. Lighting on the out-of-focus background creates a pattern of tones but does not show the actual texture of the material. The indefinite nature of the background helps give the portrait a three-dimensional feeling.

A medium gray shade of background serves for most head and shoulder portraits. Subtle tints of greens and blues enhance a background used for color. Varying the background lighting can change the shade so that a long range of tones are available from a single background.

Excellent, inexpensive backgrounds can be made from drapery fabrics. Any woven or knit material will do. Velvet is a good choice. Two widths sewn together is all that is needed. Since the background is kept out of focus, the seams will not show. Fabric with a faint pattern is particularly good. The pattern looks even more vague when it is out of focus. Variations can be made by using clips and pins to pinch sections of the material together to form patterns of random pleats. Playing the background light on these out of focus pleats can provide many variations from a single background. A white background is useful for high-key portraits. The fabric should not be a stark white. A slight off-white is best. For black and white it will photograph almost pure white. With color film white backgrounds often take on slight hues, but they are usually not objectionable.

Background paper, which comes in many different colors, can also be used. It is somewhat less practical than fabric because of its perishability. You should also consider the fire hazard of a paper background used near lights and electric wiring.

The choice of a background should never be a casual decision. A completely solid background without tone variations will give the portrait a flat appearance. It will look as though the subject's image was cut out and pasted on a background.

We are dealing with an illusion. The subject and the background must adapt to each other gracefully to form a unit—the portrait.

RED AND YELLOW FILTERS

Red and yellow filters are useful accessories for out-of-doors portraiture. When working with black and white film, the filters will make the sky photograph darker. Clouds photographed against the darkened sky take on a more dramatic appearance.

Several shades of yellow and red filters are available. The deeper the shade, the darker the sky will photograph. The sky photographs at its darkest with the red filters.

NEUTRAL DENSITY FILTERS

There are occasions in outdoor portraiture where normal shutter speed and lens aperture adjustments are unable to compensate for the presence of strong sunlight. Unless we further reduce the light passing through the lens, the film will be overexposed.

A neutral density filter is a device which cuts down on the light without changing its character. This is important

when using color film. The color balance of the light is in no way affected by the filter.

In its function as a light-reducing device, a neutral density filter can also be used for esthetic purposes. For example, a head-and-shoulder outdoor portrait with a distracting background of tree limbs would benefit from the trees being out of focus. In strong sunlight it may not be possible to use a larger lens aperture. Normally we would open the lens aperture to reduce the depth of field, thereby placing the limbs out of focus. A neutral density filter makes it possible to open the lens without overexposing the film. The filters come in several density gradations.

POLARIZERS

The sky can be made to appear bluer and darker with the use of a polarizing filter. It also makes the color of the subject's clothing more brilliant. A polarizer is used to intensify color and to reduce glare and reflection.

A deep blue sky makes a good background for a portrait. You can actually see the tonal change occur by looking through the camera view-finder. The degree of change can be controlled by rotating the filter. However, since the polarizer intensifies only the existing color, it will not change a gray sky to blue.

SUMMATION

It is reasonable to conclude that random picture taking is unlikely to produce a good portrait. Likeness goes far beyond the clinical image of a person as seen in a passport type of photograph. For our purpose as portraitists, likeness consists of the visual impression we make on others.

If you follow the disciplines covered in this book you will gain an insight to a subject's likeness that is all but invisible on first viewing. You will be able to record these visual impressions with a feeling of confidence.

Index